Images of Rail
Eastern Shore Railroad

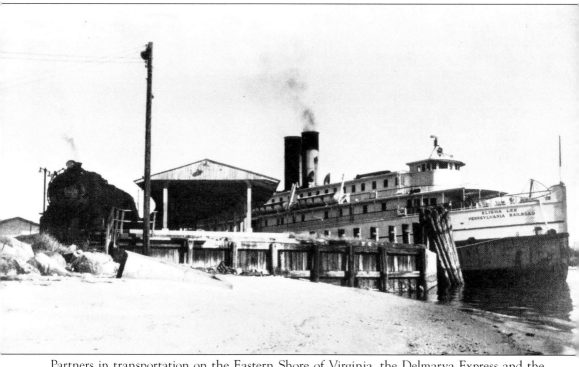

Partners in transportation on the Eastern Shore of Virginia, the Delmarva Express and the bay steamer *Elisha Lee* sit side by side in 1953 at the dock in Cape Charles. Their engines are fired up and ready to take them on separate journeys across land and sea. (Cape Charles Historical Society.)

ON THE COVER: Pulled across the Chesapeake Bay, and 1,000 feet behind the tugs that moved them, the railroad barges that traveled between Norfolk and Cape Charles were silent, moving islands and a perch for the birds of the water. (Eastern Shore Railway Museum.)

IMAGES
of Rail
EASTERN SHORE RAILROAD

Chris Dickon

ARCADIA
PUBLISHING

Copyright © 2006 by Chris Dickon
ISBN 978-0-7385-4243-0

Published by Arcadia Publishing
Charleston, South Carolina

Printed in the United States of America

Library of Congress Catalog Card Number: 2005938522

For all general information contact Arcadia Publishing at:
Telephone 843-853-2070
Fax 843-853-0044
E-mail sales@arcadiapublishing.com
For customer service and orders:
Toll-Free 1-888-313-2665

Visit us on the Internet at www.arcadiapublishing.com

Contents

Acknowledgments 6

Introduction 7

1. An Audacious Idea 9

2. Rails over Land and Sea 19

3. Under Full Steam 31

4. What Crossed the Bay 43

5. Cape Charles and the Ferries 59

6. World War II and the Automobile 81

7. At Water's Edge 91

8. Last Rides 111

Acknowledgments

The geographic area encompassed by this book was the starting point of American history, and to be sure, there are a lot of resources available to tell that history. This book draws particularly on five of them and would not have been possible without the archives they have accumulated over the years. The town of Cape Charles is the hero of this story, and its historical society and welcome center can be found in an old and preserved power plant dating back to 1947, although its considerable photograph and ephemera archive takes us back to the mid-19th century. The society's president, Marion Naar, has been tireless in bringing it all together and very generous in making it available. The Eastern Shore Historical Society, or Ker Place, is located in the home of Eastern Shore merchant, shipper, and farmer John Shepherd Ker, built in Onancock around 1800. Executive director John Verrill and archivist Mills Wehner are to be thanked for pulling the boxes of sometimes surprising photographs off the shelves and opening them up to us. Not far up Route 13 from Onancock is the town of Parksley, a planned community built by the New York, Philadelphia, and Norfolk Railroad and incorporated in 1904. It is on the town square that Helena Killian has been leading the development of the Eastern Shore Railway Museum. You can find there several historic freight, coach, and Pullman cars, a big red caboose that has recently been repainted, and binders of old photographs collected mostly from the families of past Eastern Shore Railroad workers. They contribute to some of the more personal photographs in this book. The Sargeant Memorial Room of the Kirn Library in downtown Norfolk is also a major source of photographs in this book. The author has been privileged to be able to go to this collection repeatedly over the years for television documentary production and is gratified that it can be used now in this book. Robert Lewis of Bethany Beach, Delaware, is one of those people who hold history together for the rest of us by its very sinews. His personal collection of photographs covers the transportation and infrastructure development of America east of the Mississippi going back to the beginning of photography. A day spent with Bob searching through his files is like a field trip into the last 200-plus years. Finally this book has to bow down in homage to another book. *Cape Charles: A Railroad Town*, written by Jim Lewis and published in 2004 by Hickory House of Eastville, Virginia, is a 300-page chronicle of an extraordinary American small town and a heroic piece of work. Thanks to all!

Introduction

It was not until the 1960s that the sum total of all of the world's bridge-building technology could accomplish what Alexander Cassatt had accomplished with the railroad and maritime engineering of his time in the late 19th century. Soon after the Chesapeake Bay Bridge Tunnel opened, spanning 17.6 miles across the mouth of the Chesapeake Bay, on April 15, 1964, it was deemed by the American Society of Civil Engineers as "one of the Seven Engineering Wonders of the Modern World." It took cars, trucks, and buses across 13 miles of trestles and four miles of tunnels from the tip of Virginia's Eastern Shore to Virginia Beach and Norfolk on the southern shore of the bay, and it made obsolete much of what Cassatt had created 80 years earlier: a small railroad with a remarkable audacity.

Cassatt was a wealthy railroad magnate. He would later go on to head the Pennsylvania Railroad, build the railroad tubes beneath the Hudson River, and construct Manhattan's classic Pennsylvania Station on Eighth Avenue. In 1882, he and fellow visionary William L. Scott looked at a map of America's East Coast and saw the solution to a geographic puzzle: how do you create a direct rail link from the northern commercial hub of New York City down to the southern commercial hub of Norfolk? The two cities were less than 500 miles apart, but there were 18 miles of open water to be crossed at the journey's end—not just any stretch of water, but roiling tidal water, the point at which the great Atlantic Ocean met the nation's largest natural estuary.

The task could have gone undone, after all. Virginia's Eastern Shore had been a geographic cul-de-sac since its first settling in the early 17th century. In 1879, an article in *Harper's New Monthly Magazine* said of the Shore that "it appears to be cut loose from the rest of the world, sleepily floating in the indolent sea of the past, incapable of crossing the gulf that separates it from modern life, and undesirous of joining in the race toward the wonderful future." That future was one in which post–Civil War America was ready to develop its industry and agriculture, to trade between once-antagonistic states, and to export its bounty to the rest of the world. The population and commerce on America's mid-Atlantic coast was developing exponentially, but because the portions of Delaware, Maryland, and Virginia that formed the Delmarva Peninsula were surrounded on three sides by water, the growth of population and commerce followed a bypassing arc from Baltimore, inland to Richmond, and down the western shore of the Chesapeake Bay to Newport News and Norfolk.

Cassatt saw it differently, and in 1882, he got on a horse (he was also a noted horseman), laid out a route for a railroad, and determined the location for a port from which the railroad would continue by barge and passenger steamers to the port of Norfolk. The site he chose was described by marine historian John L. Lochead as "a cornfield beside a brackish pond," but Cassatt figured it would be the most practical tidal harbor with closest access to the deep waters of the bay, and so it was there that the town of Cape Charles was built from scratch and put in business.

Cape Charles proved to be not just another small American town. As Cassatt intended, it became the point of intersection between land and sea; industry, agriculture, and the aquaculture

of the surrounding waters; and the North and South of postwar America. In the years since 1884, the railroad and the town that gave it access to the sea have ridden all of the ups and downs, booms and busts, and transportation trends of American history up to the present day. The era of the passenger steamers across the bay has long since ended, motor vehicle traffic that parallels the railroad has increased, the town of Cape Charles is always redefining itself, and at the beginning of the 21st century, the railroad still traveled down the Shore and across the bay. Like many small railroads, it had a very interesting past but could never be quite sure of what its future would hold.

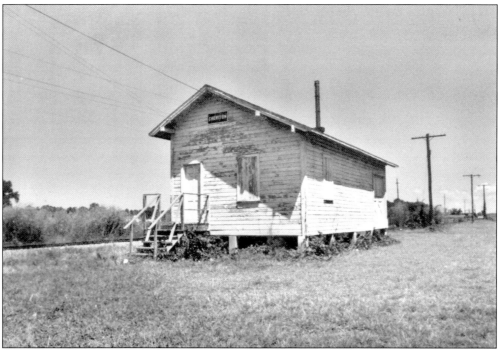

In 1884, the New York, Philadelphia, and Norfolk Railroad (NYP&N) opened for business with nine railroad stations operating on Virginia's Eastern Shore. By 1900, the railroad's success led to the opening of 11 more, including this one at Cheriton. Shown here in 1988, it was still standing, though long-since deserted at the end of the era of full and frequent passenger trains. (Eastern Shore Railway Museum.)

One

AN AUDACIOUS IDEA

This 19th-century farm on Onancock Creek might have inspired the writer of an article in *Harper's New Monthly Magazine* of May 1879. "While Plymouth Rock was all still a virgin forest, Englishmen were growing tobacco, dredging oysters and shooting wild fowl in this region," said the article of Accomack and Northampton Counties. It went on to lament the region's water-bound isolation from the rest of the East Coast. (Eastern Shore of Virginia Historical Society.)

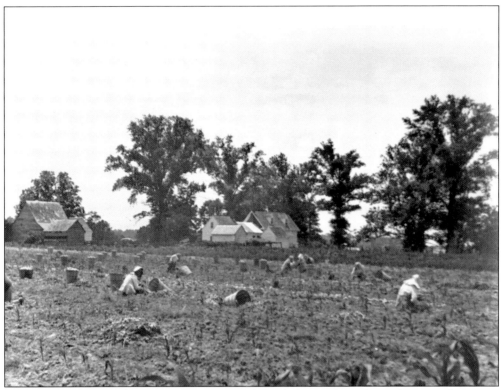

At the end of the 19th century, a mixture of freed slaves, their descendants, and migrant laborers often from the Deep South performed agricultural labor on the Shore. The beginning of a general population shift from rural to urban living was underway, and the need to export produce to the cities was increasing. (Eastern Shore of Virginia Historical Society.)

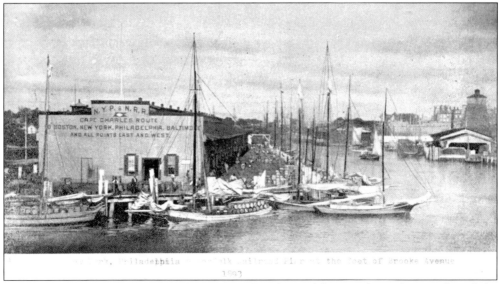

As demonstrated by this picture of the new railroad's Norfolk pier, the exchange of goods by farmers, suppliers, and buyers over land and sea would create an active market for the railroad. (Kirn Library, Sargeant Memorial Room.)

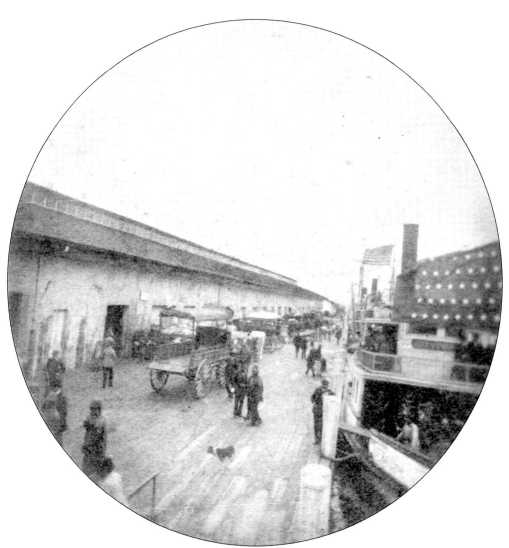

Horse and wagon wait to collect baggage and freight from an unidentified passenger ferry at the NYP&N wharf at Norfolk in 1888. This was one of the piers of Hampton Roads, a confluence of the Atlantic Ocean, Chesapeake Bay, and the Elizabeth and James Rivers. The port is touched by the surrounding cities of Virginia Beach, Norfolk, Portsmouth, Chesapeake, Suffolk, Newport News, and Hampton. It is considered to be one of the world's largest natural harbors but was not very active until the first railroads came to its cities, beginning in 1834. By the end of the century, Norfolk would be the largest of the cities, with a population near 45,000. This wharf and its surroundings would serve the railroad in various ways well into the 20th century. (Kirn Library, Sargeant Memorial Room.)

Alexander Cassatt is chiefly credited with building the railroad. Cassatt was a Pennsylvania Railroad (PRR) vice-president, brother of the Paris-based impressionist painter Mary Cassatt, and a graduate of Rensselaer Polytechnic Institute, esteemed by others as an "engineering genius." When the idea of the railroad was first proposed unsuccessfully to the Pennsylvania Railroad by multi-millionaire William L. Scott, Cassatt resigned his position and joined Scott in looking at the geographic challenge of Virginia's Eastern Shore in a different way.

Prior to 1884, a number of rail lines ventured into Delaware and Maryland, the upper states of the Delmarva Peninsula, but their ability to connect west and south was problematic. To find a better way, Alexander Cassatt mounted a horse and performed his own survey of a railway that would travel down to the tip of Virginia's Eastern Shore, to a site that was known locally as "Mud Creek."

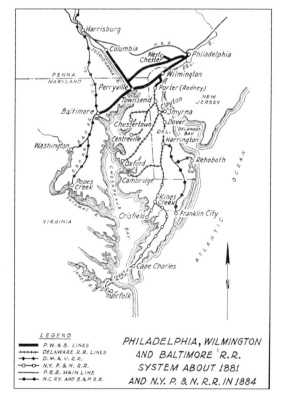

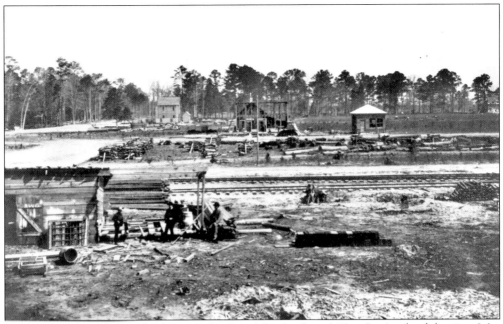

The site was 64 miles south of Pocomoke City, Maryland, and 11 miles north of the tip of the peninsula. Much of the land for the new railroad's operation in Cape Charles was deeded from the estate of the late Virginia governor and U.S. Senator Littleton Tazewell. Full dredging of the harbor took two years beginning in 1883, but the railroad track to the bay was completed by October 25, 1884. (Cape Charles Historical Society.)

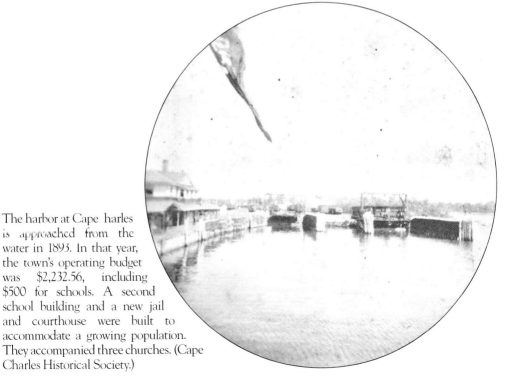

The harbor at Cape Charles is approached from the water in 1893. In that year, the town's operating budget was $2,232.56, including $500 for schools. A second school building and a new jail and courthouse were built to accommodate a growing population. They accompanied three churches. (Cape Charles Historical Society.)

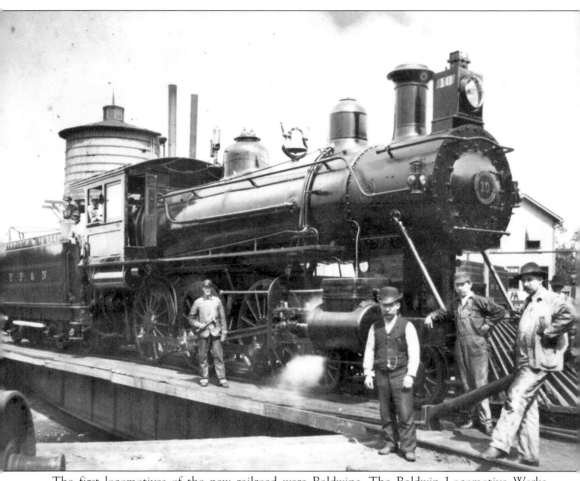

The first locomotives of the new railroad were Baldwins. The Baldwin Locomotive Works produced steam locomotives in Philadelphia starting in 1831 for the Pennsylvania Railroad; the Baltimore and Ohio (B&O); Atchison, Topeka, and Santa Fe; and for railroads in Europe, Egypt, India, and Haiti. At the turn of the century, rapid change in the development of technology and power of locomotives led to this Compound Consolidation Locomotive, 95-and-a-half feet in length. Cape Charles's shop foreman, Jesse Oren (in vest and derby), stands with his crew before a 1902 Baldwin locomotive on a yard turntable. Mr. Oren was perhaps typical of the supervisory workforce for the new railroad. Born in the PRR town of Palo Alto, Pennsylvania, in 1863, he worked railroad shops there before transferring to Cape Charles, where he and his wife, Mary, had four children. One of his sons, William, went on to serve in World War II as captain of a railroad battalion in support of European railroads. (Cape Charles Historical Society.)

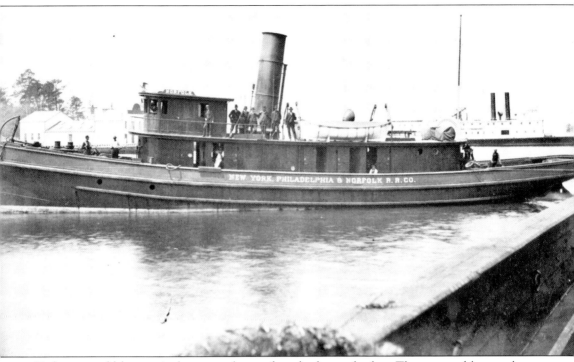

Tugboats would be required to move barges from harbor to harbor. The tugs and barges that worked for the NYP&N would undertake the rail barge journey across the bay west to the Elizabeth River and downriver to the pier in Norfolk. At 36 miles, this was the longest such journey yet attempted in American waters, first taken on March 12, 1885. The tug *Norfolk*, shown on May 30, 1886, was among the first of those built for the railroad. The picture offers a rare photographic look at the first ferry built for the NYP&N, the *Cape Charles* (background). The paddlewheel steamer could travel at 20 miles per hour and carried one set of railroad tracks down each side of her deck, a configuration planned to accommodate four Pullman cars to be transported across the bay and connected with the Southern Railroad. The *Cape Charles*, though, had difficulty maneuvering in Cape Charles harbor, and the Pullman service could not keep up with published schedules. The boat became a charter in 1888 and left regular service. (Courtesy of Robert Lewis.)

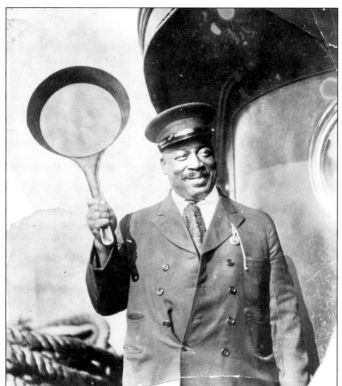

The tug *Cape Charles* used an onboard crew of 12, including its own cook, J. H. Smith, shown on April 25, 1924. At that time, 10 tugboats were in almost constant use, 8 owned by the PRR and 2 chartered. In May 1924, all previous records were broken when tugs and barges moved 19,557 freight cars across the bay. (Cape Charles Historical Society.)

A barge waits to be fully loaded at Cape Charles in 1898. A navigation bridge that rose above the level of the railroad cars topped each barge. The cars were tied down by turnbuckles and cables. Barely visible out in the bay are the four-masted sailing schooners typical of the time. (Cape Charles Historical Society.)

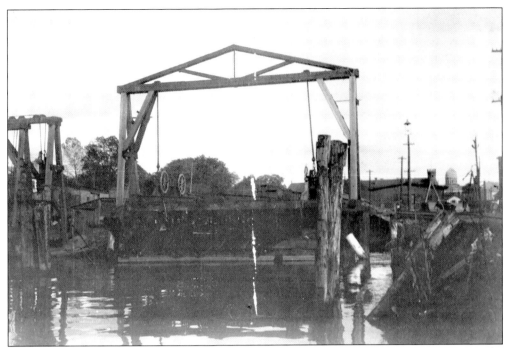

A tug and barge dock are at the other end of the journey in Norfolk in the late 19th century. The domed building in the far distance at right is Norfolk City Hall. In the late 20th century, it became the memorial and burial place of Gen. Douglas MacArthur. (Cape Charles Historical Society.)

Freight cars that arrived at the Norfolk pier were often connected with other railroads by movement along Water Street, as shown here in 1914. Connections were also made with other floats and yards of the region, supplemented by the Norfolk and Portsmouth Belt Line Railroad, developed in 1898 to exchange rail cars throughout the port area. (Kirn Library, Sargeant Memorial Room.)

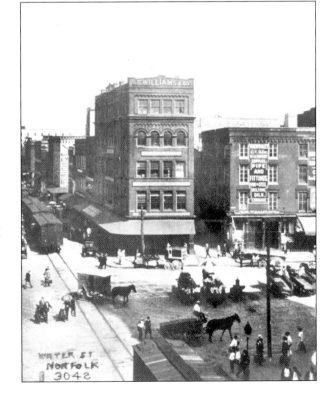

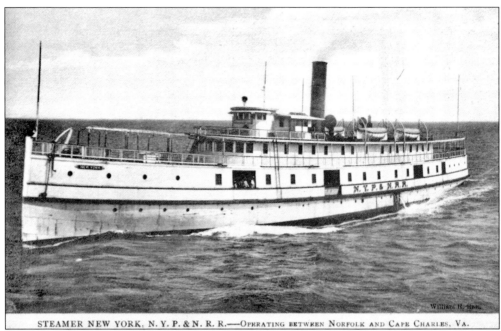

STEAMER NEW YORK, N. Y. P. & N. R. R.—OPERATING BETWEEN NORFOLK AND CAPE CHARLES, VA.

The passenger steamer *New York* is pictured at sea and in a postcard view of Cape Charles Harbor. The *New York* was built for the NYP&N by Harlan and Hollingsworth Ship Builders in Wilmington, Delaware, in 1889 at a cost of $125,000. In 1910, most of its superstructure was destroyed in a fire at the Norfolk piers. In 1932, the *New York* was quickly destroyed again by fire in port at Staten Island, New York. The structure was converted to barge use in North Carolina and abandoned in 1941. (Top: Eastern Shore Railway Museum; bottom: Cape Charles Historical Society.)

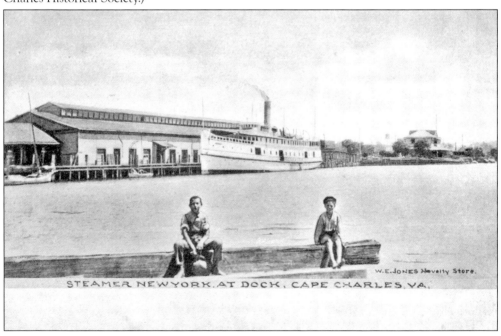

Two

RAILS OVER LAND AND SEA

Much of the railroad's right-of-way through Virginia was donated by farmers. In an editorial dated April 27, 1882, *The Peninsula Enterprise* urged readers to " 'fall in' and 'close up the ranks,' and let the glad tidings go forth that the last obstruction to the building of a direct line to New York has been removed." It promised that doing so would "repay ten-fold the landowner for the sacrifice of a very few hundreds of feet." (Cape Charles Historical Society.)

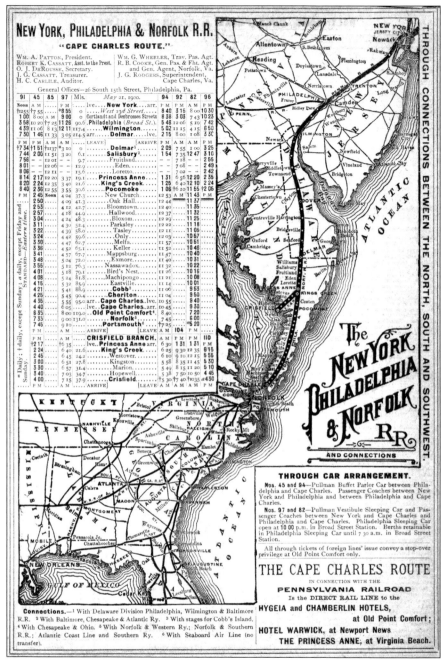

A schedule and route map shows a path through New York and Pennsylvania and down the Delmarva Peninsula—Delaware, Maryland, and Virginia—in 1900. Overnight passenger travel between New York City and Norfolk took just over 12 hours, including the connection from train to ferry in Cape Charles. The map also shows that Delmarva service stopped in many more small stations per 10-mile distance than any other section of the full run from New York. Many of those towns had been created by the railroad's presence. Railroads and their schedules were so prolific in 1900 that an annually published book of U.S. railroad schedules was as thick as a modern-day telephone book for a mid-sized city. (Kirn Library, Sargeant Memorial Room.)

An early passenger train approaches Delmar from the north. The town of Delmar was created in 1859 when, by law, railroads of Maryland and Delaware could only be extended to state boundaries. At the point where the two railroads met, a town was formed on both sides of the state line. Eventually the town came to fall under the jurisdiction of the state of Maryland. (Courtesy of Robert Lewis.)

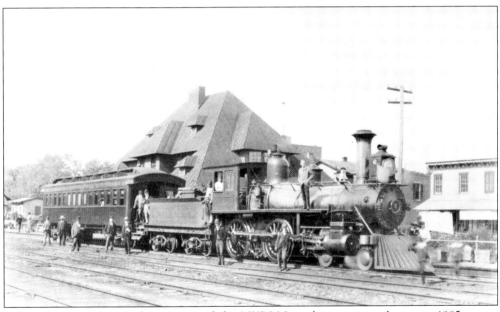

Delmar blossomed with the coming of the NYP&N, and its station, shown in 1885, was a point of great civic pride. Delmar had become the midpoint of any north-south transit of the Delmarva Peninsula and a point for crew changes and railroad maintenance. That brought highly skilled workers to the town, which rose to a population of 680 by the year 1889. (Courtesy of Robert Lewis.)

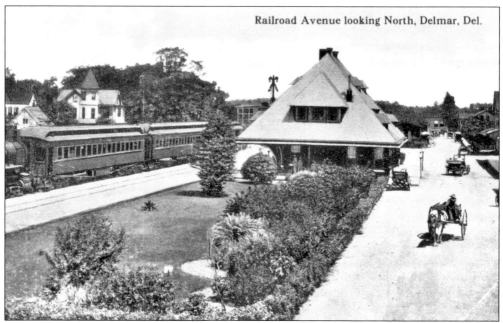

A postcard offers a picture-perfect view of Delmar Station in 1913. Near mid-century, relations between the town and the railroad would sour with the railroad's economic decline. When the railroad offered to sell the station to the town for use as a public building for $1, town leadership refused to make the purchase. The station was torn down, but controversy about the failed transaction has lingered into the 21st century. (Courtesy of Robert Lewis.)

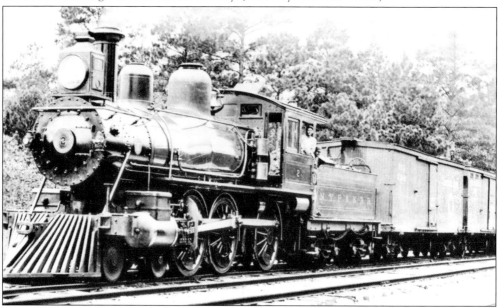

Freight was as important as passengers in the operation of the NYP&N, running here south of Delmar. In 1903, the conversion of freight cars to air brake control was begun. Most cars had a 20,000-pound capacity; only a few could accommodate 60,000 pounds. Slower freight rains that carried lumber and other heavy material could not exceed 60 cars in length. (Courtesy of Robert Lewis.)

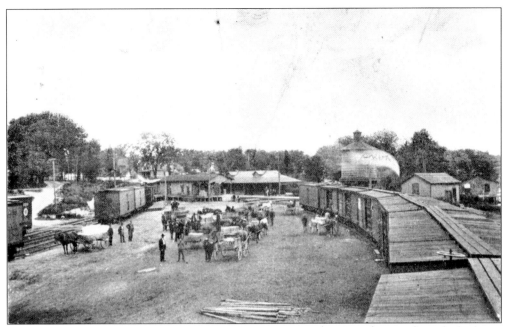

Potatoes were an important crop on the Delmarva Peninsula. Here they are brought by horse and wagon to the station in Seaford, Delaware, in 1907. Seaford, on the waters of the Nanticoke River, had been a point of exploration as English captain John Smith set out to discover the Chesapeake Bay in 1608. By the 20th century, it was a thriving water and agriculture town of 2,000. (Courtesy of Robert Lewis.)

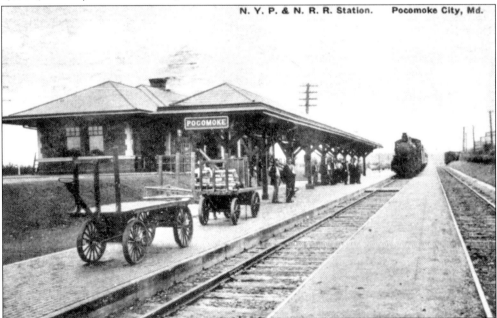

It was from Pocomoke, Maryland, that the NYP&N set out on its new route due south to Cape Charles. At the time, Pocomoke was a shipbuilding town on the river of the same name and a water port with connections to Baltimore, New York, and Philadelphia. (Eastern Shore Railway Museum.)

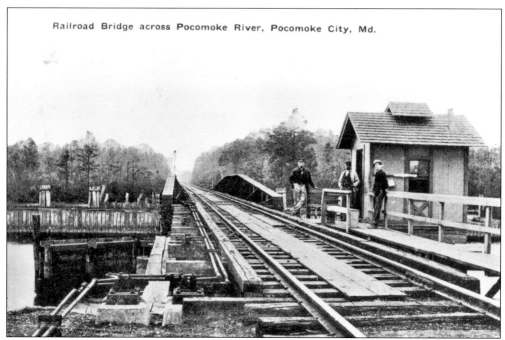

Alexander Cassatt designed the movable railroad bridge across the Pocomoke River. As an engineer, Cassatt seemed to love the challenge of crossing water. He would become president of the PRR, and during his tenure, he would be responsible for development of the Hudson River crossings that would allow rail traffic to enter New York City: the Hudson River tubes into midtown Manhattan and the Hell Gate Bridge across the East River. (Courtesy of Robert Lewis.)

Some of the first locomotives were wood burning, thus the stack of logs set near the mainline from Pocomoke to Cape Charles in 1884. (Cape Charles Historical Society.)

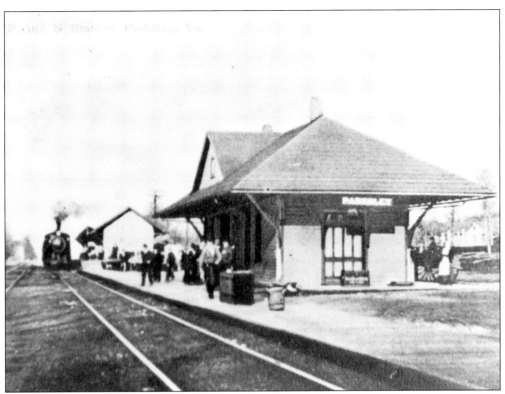

Parksley, Virginia, was one of the first planned communities in the United States. In 1884, Henry Bennett purchased 160 acres of farmland and laid out a town grid with a commercial district near the railroad, designated locations for schools, parks, and churches, and a section segregated for African Americans at the edge of town. Community rules required that any parcel on which alcohol was consumed would be forfeited back to the development company. Melfa, below, sat 10 miles south of Parksley on the NYP&N line. The town was named after an official of the new railroad. (Eastern Shore Railway Museum.)

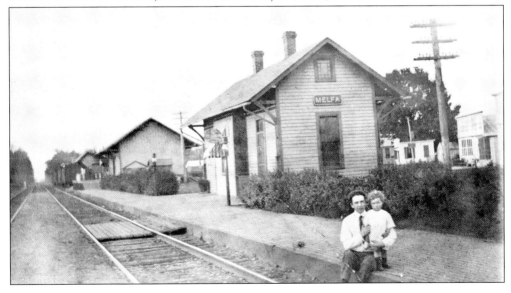

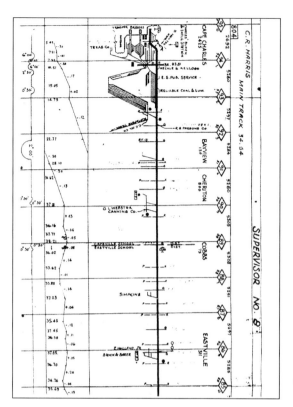

A track map and its legend detailed the last 10 miles of the right-of-way through Eastville and Cheriton to Cape Charles. Available documents from the railroad's operation since 1884 show meticulous planning, mapping, and record keeping. In 1902, the railroad began to replace its track with 85-pound steel rails, using the old track for sidings. On October 11, 1904, the Cape Charles yard's electricity plant was turned on. Telephone dispatch replaced the telegraph in 1912. (Cape Charles Historical Society.)

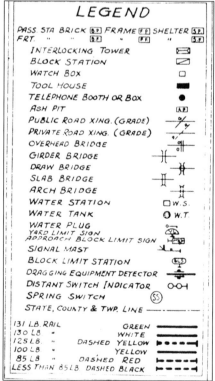

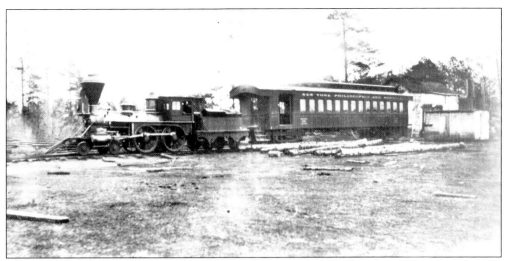

The last spike in the rail at Cape Charles was driven in the late afternoon of October 25, 1884, culminating the effort of a 1,100-man workforce. This may be the first passenger train to arrive in the town. The first through express train to New York is believed to have left on the evening of November 17, averaging 40 miles per hour to the stop in Wilmington, Delaware. (Courtesy of Robert Lewis.)

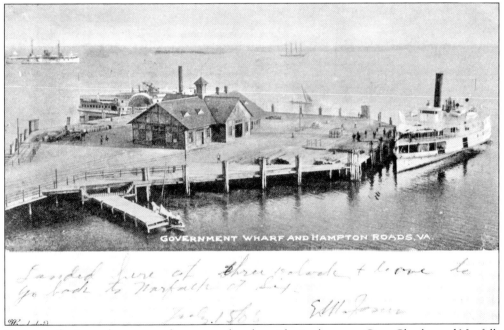

Passenger ferries and steamers often stopped at the midpoint between Cape Charles and Norfolk at Government Wharf (later Old Point Comfort) in Hampton. The paddlewheel steamer *Northampton*, in the background, had played an active role in the Civil War as a troop and prisoner transport under Confederate flag. (Eastern Shore Railway Museum.)

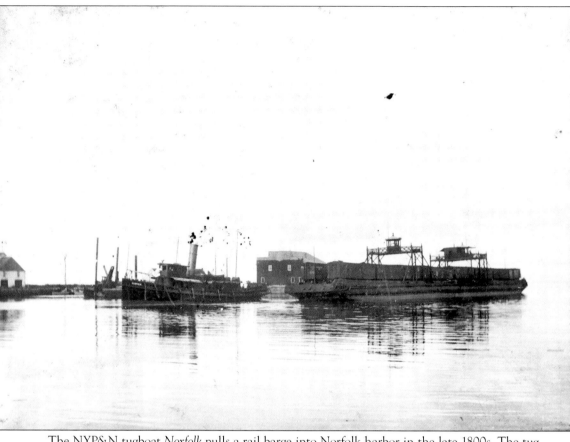

The NYP&N tugboat *Norfolk* pulls a rail barge into Norfolk harbor in the late 1800s. The tug, with 915 horsepower and a crew of 12, was one of the most powerful of all tugs built up to that time. The first such crossing took place on March 12, 1885, as the *Norfolk* successfully towed Barge No. 1 laden with 12 rail cars from port to port. Some had doubted that the journey could reliably take place on the sometimes-perilous waters at the mouth of the Chesapeake Bay, a concern borne out, for example, by the loss of two freight cars tossed overboard in a February gale in 1886. But initial success was followed by steadily increasing travel and the addition of tugs and barges to do the work. (Kirn Library, Sargeant Memorial Room.)

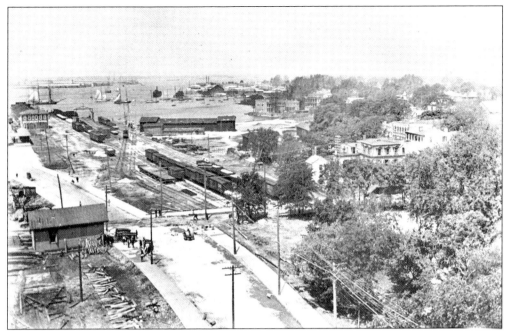

The profile of a passenger steamer, left of upper center, approaches through the masts of small sailing ships in Norfolk harbor in 1899. Passenger steamers were a presence in the harbor long before the advent of the railroad. The first of them arrived in 1813 as a popular form of overnight transportation between Norfolk, Baltimore, and other points. (Kirn Library, Sargeant Memorial Room.)

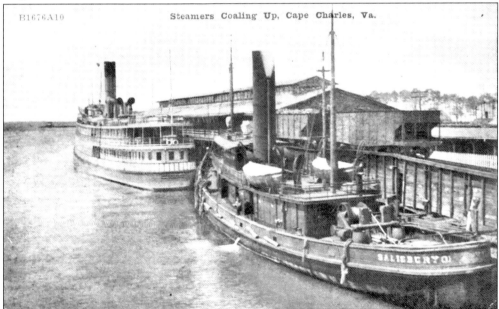

At Cape Charles, tugs and passenger steamers were coaled up from coal cars run by the railroad. The tug *Salisbury* was built by J. H. Dialogue and Son of Camden, New Jersey, in 1900. She generated 1,200 horsepower with a triple expansion steam engine and measured 123.9 feet long with a beam of 25.9 feet. (Cape Charles Historical Society.)

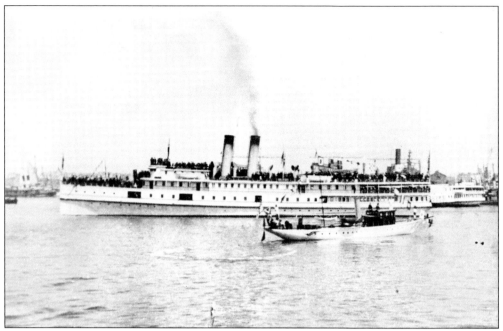

The steamer *Pennsylvania* is shown above near Newport News, Virginia, in 1900, and below at the Norfolk dock in 1912. The *Pennsylvania* was a twin-screw freight and passenger ferry. With four-cylinder engines and 3,300 horsepower, she was thought to be the fastest boat on the Chesapeake Bay in her first years. Built in 1900 by the Delaware River Company of Chester, Pennsylvania, she ran almost continuously until scrapped in 1950. (Kirn Library, Sargeant Memorial Room.)

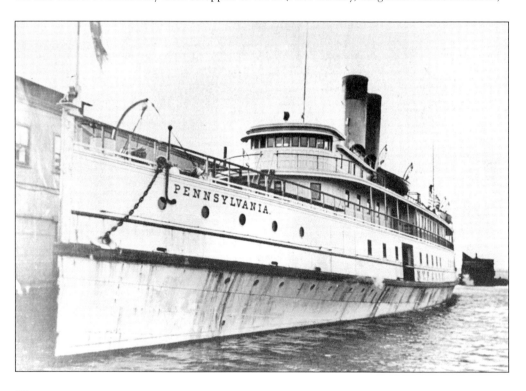

Three
UNDER FULL STEAM

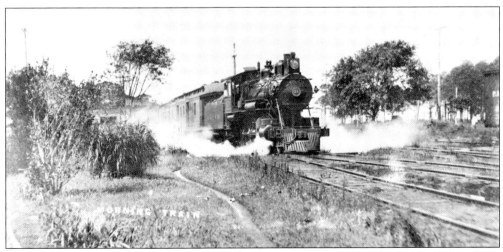

A quick success in its first years, the NYP&N operated at full steam in the first half of the 20th century. In 1906, post-dividend profit was $600,000. In 1907, the year of this picture near Cape Charles, the company's gross earnings were $3,181,149. (Cape Charles Historical Society.)

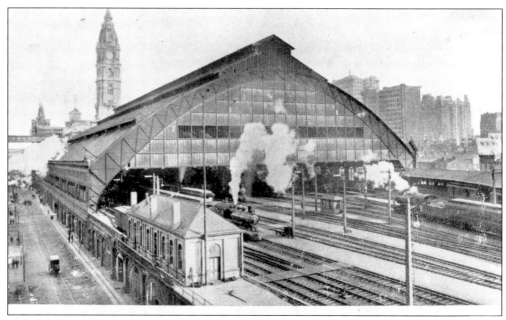

Philadelphia's Broad Street Station, seen in this postcard dated 1910, was a large feeder of passengers and freight into the NYP&N system. The station was opened in 1881. Tracks seen leading out of the shed were laid on a retaining wall that came to be known as "the Chinese Wall," which extended three-quarters of a mile and seemed to divide the city down its middle. (Courtesy of Robert Lewis.)

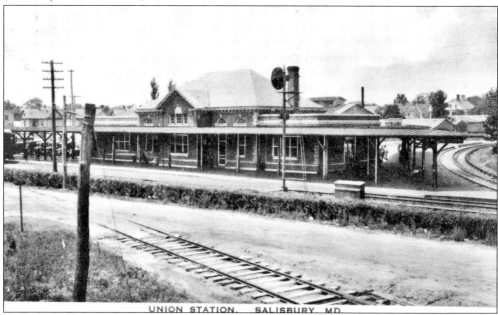

Salisbury in 1920, 120 miles down the line, was like many of the larger stations that fed other rail lines into the NYP&N route. On the Wicomico River, Salisbury was a port of the Chesapeake Bay in the early 18th century and a southern terminus for northeast railroads in the mid-19th century. The track at the right is a feeder of the Baltimore, Chesapeake, and Atlantic Railroad (BCA). (Courtesy of Robert Lewis.)

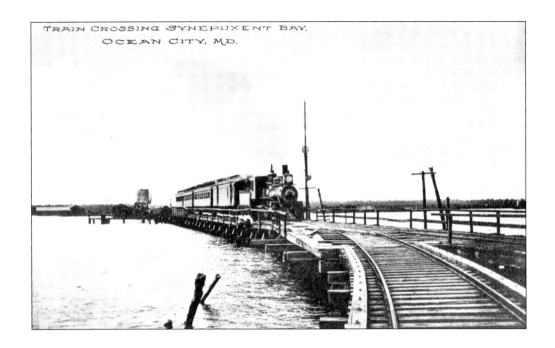

Running through Salisbury from Ocean City on the Atlantic coast of Maryland to towns on the Chesapeake Bay, the BCA starts the journey with its own short bay crossing in 1912. The bridge was built over the Sinepuxent Bay in 1876. When not in use by trains, wooden planks were placed between the rails to allow foot and horse traffic. Berlin, Maryland, lay halfway between Ocean City and Salisbury on the BCA line. (Courtesy of Robert Lewis.)

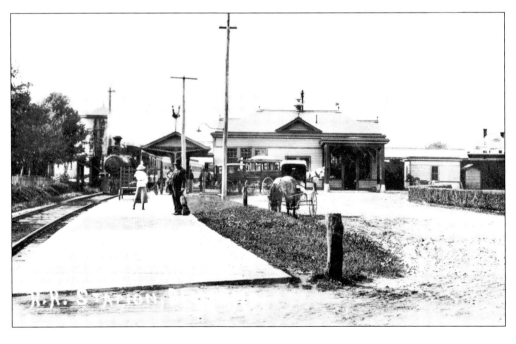

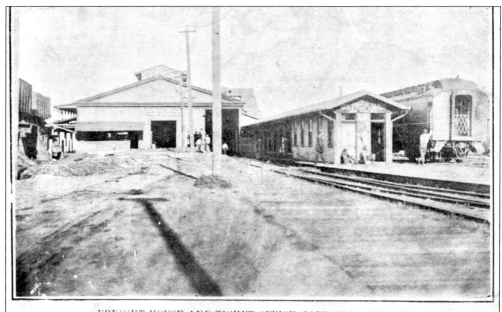

FREIGHT HOUSE AND TICKET OFFICE, CAPE CHARLES, VA.

By 1909, the station at Cape Charles was fully laid out for freight and passenger traffic, and the railroad was ready for expansion at its southern terminus. Gross earnings for the railroad had exceeded $3 million two years earlier, new steamers and barges had entered the fleet, and the PRR had taken over operating control in 1908. The facility was ready for vast expansion. (Eastern Shore Railway Museum.)

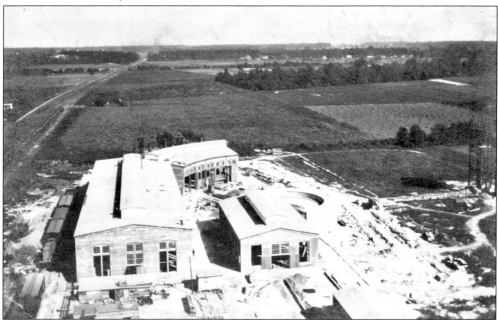

The year 1910 saw the movement of 184,281 freight cars across the bay. That quantifier of the railroad's success accompanied a major investment in the construction of new offices, electrified maintenance shops, and classification yards in Cape Charles—the first large undertaking for capacity development since 1884. (Cape Charles Historical Society.)

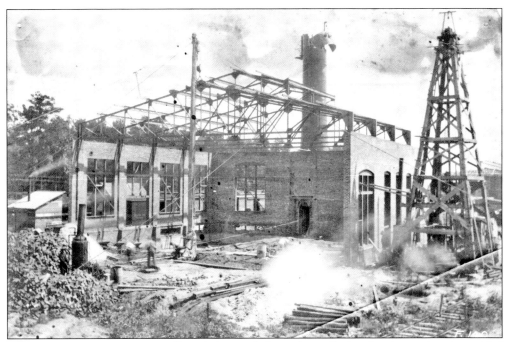

The power generating station allowed electric light and ventilation for the yard and provided excess power to the town of Cape Charles. Light and ventilation were enhanced comforts for the new facility, and all buildings were constructed of brick and heated by steam. Tools were now run by electricity where desirable, and the railroad could now repair all of its cars and locomotives as needed. (Cape Charles Historical Society.)

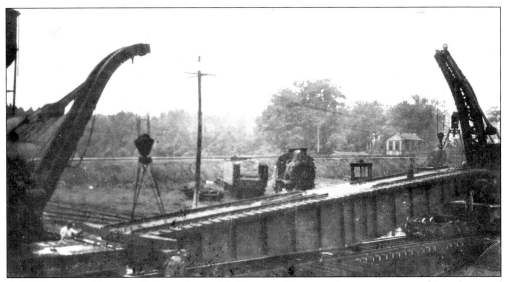

A 75-foot turntable served six tracks and fed cars and locomotives to a new machine shop and engine house and the active rail yard. (Cape Charles Historical Society.)

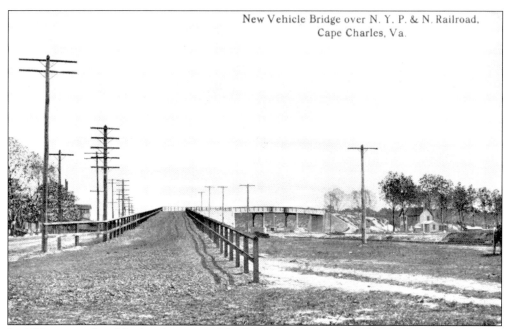

In 1912, an overhead bridge, known as "the hump," was constructed over the track at a busy road into Cape Charles. It allowed switching operations to work without interruption and replaced the need for a gatekeeper, whose function often became one of preventing residents from entering their town. (Eastern Shore Railway Museum.)

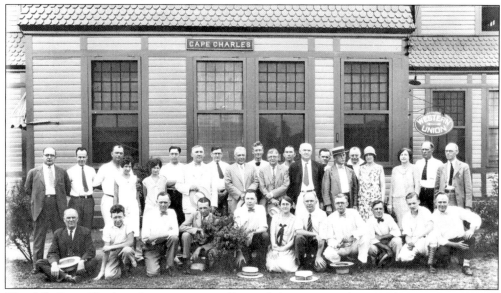

The full Cape Charles administrative staff joined for a group photograph in 1929. Pictured from left to right are (seated) H. D. Travis, Frances Detwiler, C. H. Hudson, W. H. Mapp, C. I. Gaskill, Nell Harrington, B. B. Stevenson, A. F. Dize, John Baugh, Milton Stevenson, and H. W. Layfield; (standing) Dr. Hunter, medical examiner; V. C. Taylor, J. L. Warren, Minnie Disharoon, Gladys Johnson, H. L. Standbridge, I. J. Burbage, I. L. Swann, G. W. Curtiss, E. J. Hunt, J. J. Restein, E. T. Warner, H. J. Esham, M. E. Culver, J. D. King, H. K. Lockhart, Etta Mercer, Lola Churn, J. W. Dillahunt, and J. H. Powell. (Eastern Shore Railway Museum.)

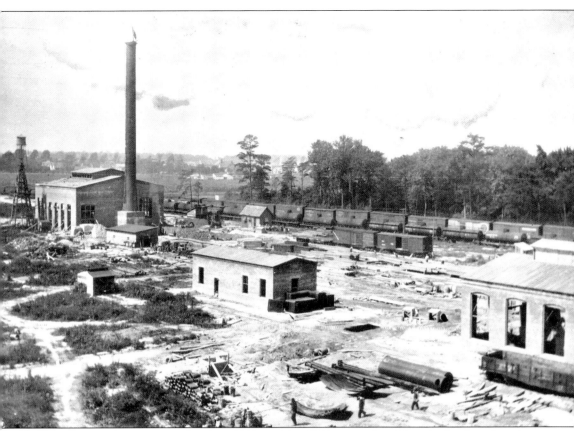

The new complex was completed in 1911, and by 1920, it employed hundreds of workers in round-the-clock shifts. In that year, Cape Charles supported three daily round-trip trains to New York and as many as 1,400 freight cars per day. The passenger steamers had a reputation for being among the best-maintained water vessels in the country. Hospitality and food services for passengers on land and sea were compared to that of the finest hotels. Automobiles were increasingly being transported across the bay, and, in recognition of the growing reliance of the population on their cars, the Interstate Commerce Commission ordered the railroad to significantly reduce its charges for automobile transport on the ferries to $4.23 for cars under 2,000 pounds and $8.26 for those over. (Cape Charles Historical Society.)

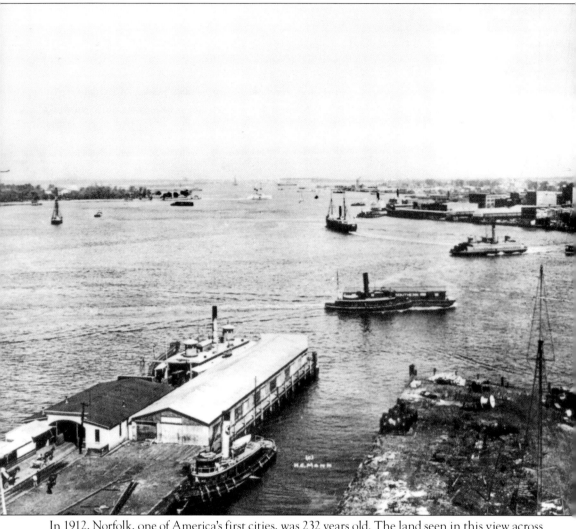

In 1912, Norfolk, one of America's first cities, was 232 years old. The land seen in this view across the Elizabeth River from Portsmouth was purchased in 1680 under order of King Charles II. The king also directed that ships calling at the city land only in certain places, thus concentrating the work of a port town that sat less than 20 miles inland from the Atlantic Ocean. British forces attacked and burned the town to the ground on January 1, 1776. By the early 20th century, the port of Norfolk exceeded activity in other East Coast cities such as Baltimore, Philadelphia, and

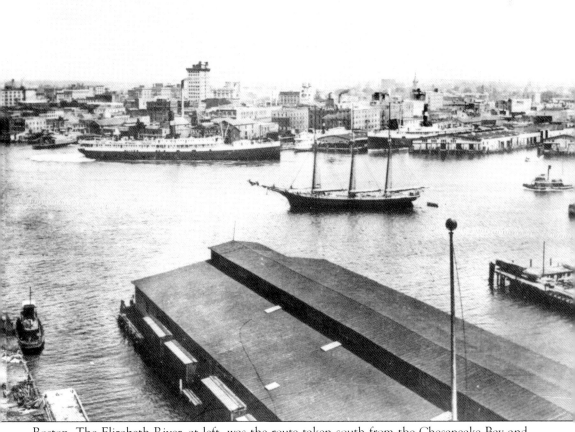

Boston. The Elizabeth River, at left, was the route taken south from the Chesapeake Bay and was crossed by ferryboats between Norfolk and Portsmouth. Sailing schooners still carried much of the world's ocean-going freight. The long passenger boat heading toward a pier is the bay steamer *Princess Anne*. The comings and goings of the NYP&N steamers and barges fed into the mix. (Kirn Library, Sargeant Memorial Room.)

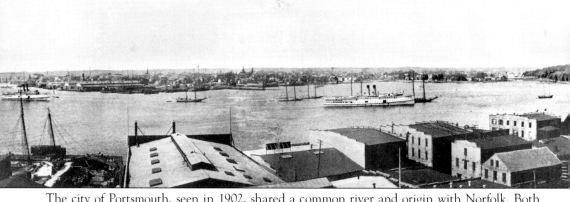

The city of Portsmouth, seen in 1902, shared a common river and origin with Norfolk. Both were named after the British cities from which the first settlers had come, and their waterfronts faced each other across the Elizabeth River. The Portsmouth waterfront was the site of the country's oldest industrial shipyard, now the Norfolk Naval Shipyard, which produced one of the navy's first battleships, the USS *Chesapeake*, in 1799. In the relatively modern times of the early 20th century, the waterfront was home to the extensive facilities of the Seaboard Airline Railway. The Portsmouth waterfront also included Port Norfolk, a rail yard used by the NYP&N, and other railroads. Just as the Seaboard Airline Railway, developed in the late 19th century, was not what its name might imply, Port Norfolk and the shipyard were named after the largest city on the water, though they were contained in Portsmouth. (Kirn Library, Sargeant Memorial Room.)

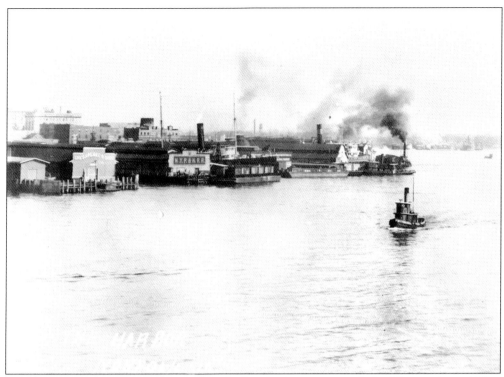

By 1912, the NYP&N shared a terminal on the Brooke Avenue pier with the Chesapeake and Ohio Railroad (C&O). Along with the Norfolk and Western Railroad, the C&O had a large freight presence in the port, especially in the export of coal. It ran its own ferries between Norfolk and Newport News, where it had a passenger terminus. (Kirn Library, Sargeant Memorial Room.)

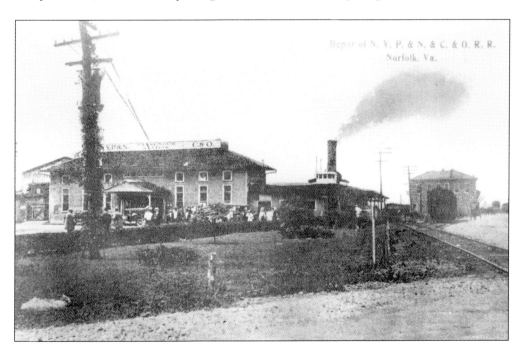

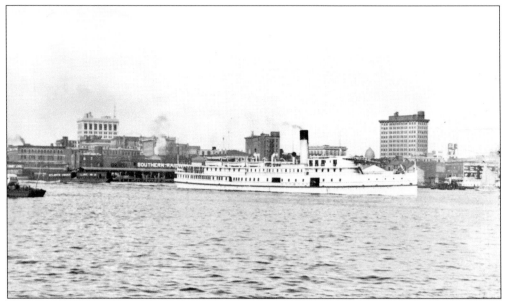

The NYP&N passenger ferry *Pennsylvania* is pictured off the Brooke Avenue pier in 1913, passing the piers of the Atlantic Coast Line and Southern railroads. Almost none of the NYP&N (later PRR) steamers managed to get through their life spans without various mishaps. On October 25, 1905, the *Pennsylvania* destroyed much of the Cape Charles pier while trying to dock in a gale. In January 1906, she ran aground in heavy seas two miles out of Cape Charles harbor, and in 1931, a lightning strike destroyed much of her upper decking. (Kirn Library, Sargeant Memorial Room.)

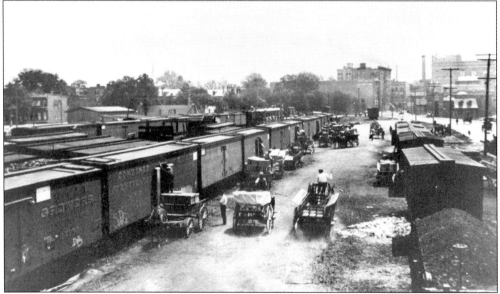

Trains, horses, and wagons brought constant activity to the freight yard at Brooke Avenue in 1906. Just north of the yard was the Freemason District of Norfolk, since the mid-19th century the city's most fashionable neighborhood. Many of its mansions still stand in the 21st century, and cobblestone streets have yet to be covered with cement and asphalt. (Kirn Library, Sargeant Memorial Room.)

Four

WHAT CROSSED THE BAY

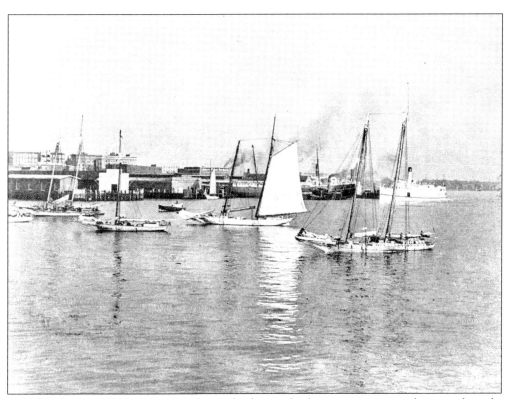

In 1913, the port of Norfolk, and the trade that took place on its piers and waters, brought together large and small businesses, passengers, and farmers who often came to market in small skiffs. The PRR had taken over control of the NYP&N in 1908, and the railroad was in full stride with average annual net earnings of $1 million. (Kirn Library, Sargeant Memorial Room.)

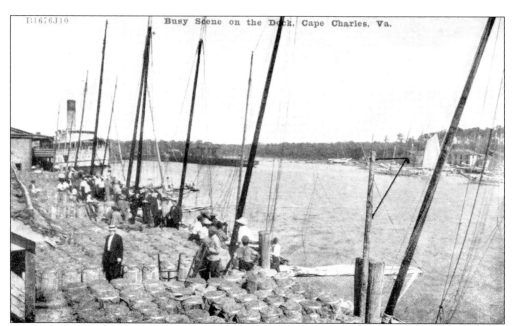

In 1916, a total of 259,181 freight cars were transported across the Chesapeake Bay by NYP&N tugs and barges. That would have represented only a portion of the north and south movement of freight by the railroad, much of it the produce of agriculture and the bay waters in freight cars and in bulk, as seen on the docks at Cape Charles. (Eastern Shore Railway Museum.)

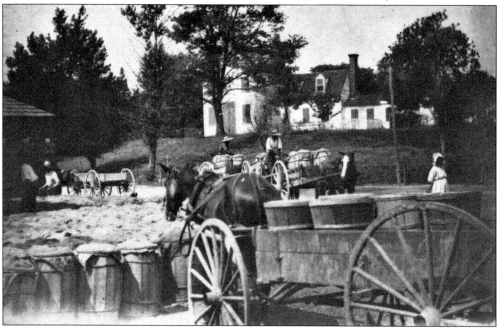

Workers load potatoes picked from the Alicia Hopkins home in Onancock. Its name taken from the Indian word for "foggy place," Onancock's access to the Chesapeake Bay and its active wharf on Onancock Creek made it a center of trade on the Eastern Shore. It is the location of the Eastern Shore of Virginia Historical Society, or Ker Place, named after 18th-century merchant and farmer John Shepherd Ker. (Eastern Shore of Virginia Historical Society.)

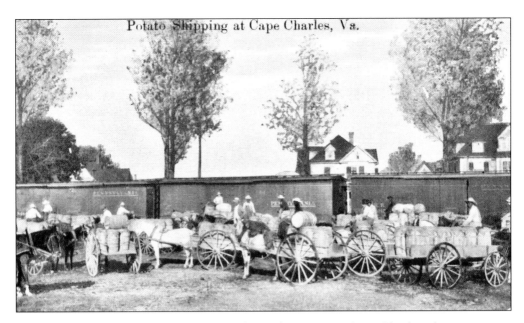

Baskets of potatoes were constantly brought to the trains at Cape Charles when in season. In May 1920, potato shipments exceeded the capacity of NYP&N freight cars, and potatoes waiting for shipment at stations along the line began to crowd out other produce. At one point, the small stations at Eastville and Bloxom were shipping between 25 and 30 cars of potatoes daily. In 1918, all of those involved in the Shore's potato trade, it seemed, gathered on the dock at Cape Charles. (Top: Eastern Shore Railway Museum; bottom: Cape Charles Historical Society.)

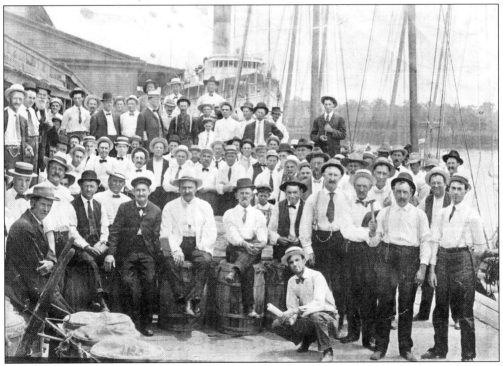

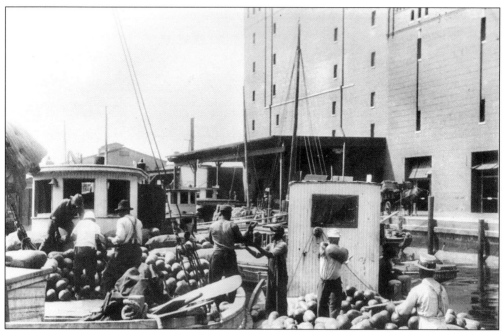

Watermelons and cantaloupes were among the most successful of truck crops in the farms surrounding Norfolk. In 1919, watermelons were brought in abundance by small boats from the farms near inland rivers. They were sold in the city's active City Market and exported by train and boat up and down the East Coast. (Kirn Library, Sargeant Memorial Room.)

Oysters were an important product for export and local consumption along most of the railroad's route. Hand-tonged from shallow waters in and around the lower Chesapeake Bay, they were brought to the Brooke Avenue piers in 1939 for local and coastal markets. (Kirn Library, Sargeant Memorial Room.)

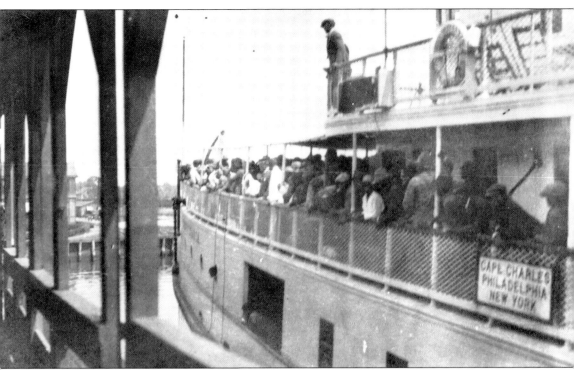

As envisioned, the railroad's quick ability to deliver perishables like strawberries to East Coast markets led to a growing demand for that crop. On May 12, 1922, for example, the railroad shipped 100 freight cars of the fruit to northern markets. PRR stations up and down the line sometimes became auction sites for the produce brought in from far-flung agricultural sources. The PRR had also moved into subsidiary businesses that paralleled those of its customers by manufacturing products of the very raw materials it carried as freight. In doing so, it had the added advantage of being able to move its labor forces wherever needed. On the Eastern Shore of Virginia, that ability was particularly effective, as workers could be moved from country to city by a pleasant 90-minute boat ride. (Cape Charles Historical Society.)

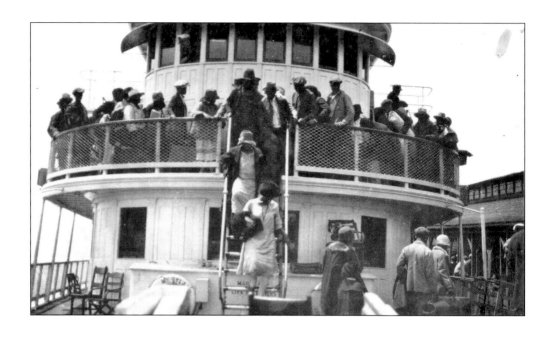

In the late 1920s, the PRR went into the strawberry-juice business. Workers who picked and packed the strawberries in the field were brought by ferry steamers to processing plants in Norfolk. These workers moved from the ferry to a strawberry-juice plant on St. Julian Avenue, Norfolk, seen on May 7, 1929. (Cape Charles Historical Society.)

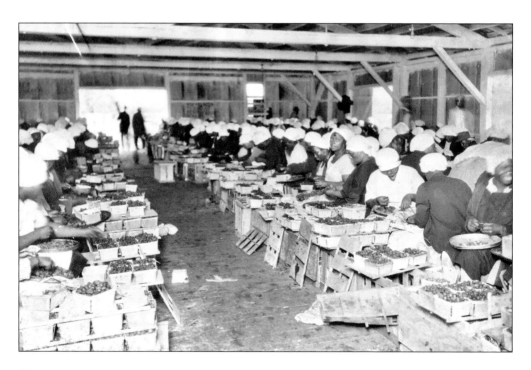

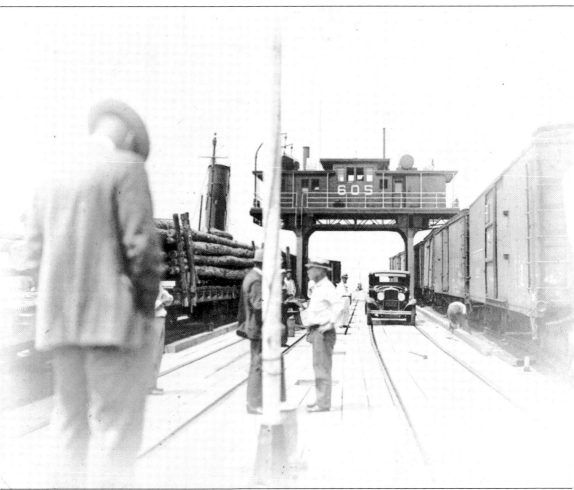

In 1920, the operation at Cape Charles was handling an average of 300 freight cars per day, and on June 27 of that year, it pulled more than 1,500 loaded freight cars north through Delmar. As a central East Coast shipping point for agriculture and seafood, the harbor was one of the busiest of its size in the country. The tug and barge operation often had to lease extra tugs, and at one point, it moved 600 cars north from Norfolk to Cape Charles in one day. That business would only increase as the 1920s roared on. The barges were places for freight of all kinds and meeting places on which to conduct the business of the day. Barge No. 605, seen here later in the 1920s, plied the waters of the lower Chesapeake Bay from 1926 to 1973. (Cape Charles Historical Society.)

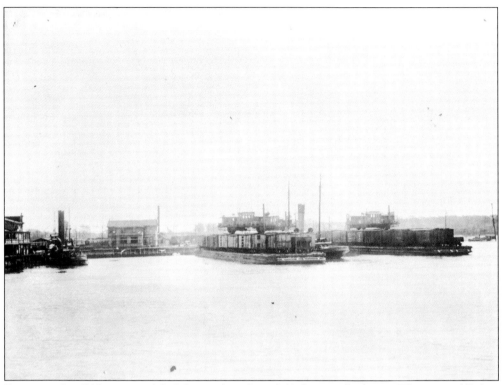
Barges in the 1920s averaged 340 feet in length and 49 feet on the beam. They were filled to capacity and prepared for the journey across the bay. Within the harbors, tugs used the method of abreast towing, in which the tug and barge were lashed together side by side for optimal control in generally safer and shallower waters. (Cape Charles Historical Society.)

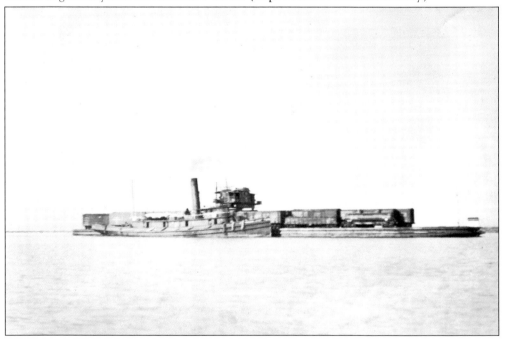

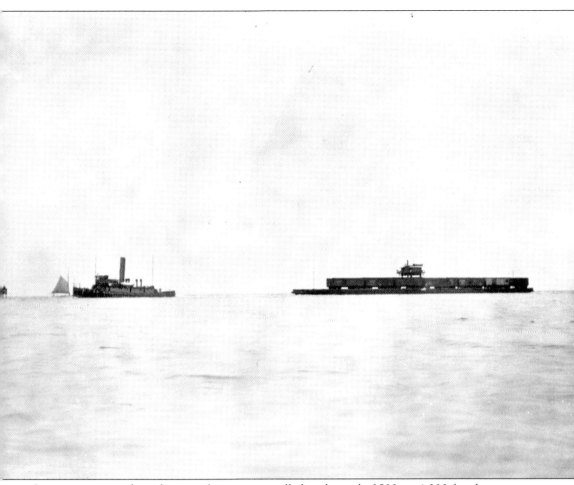

In open waters and rougher seas, barges were pulled at the end of 500- to 1,000-foot hawsers to lessen the chance of damage to either vessel. Crossing the bay was a towing operation and took approximately four hours under optimal conditions. The number of freight cars pulled across the bay grew with each year. In 1900, 46,136 cars were floated, and 259,053 crossed in 1923. *The Eastern Shore News* reported that on June 27, 1924, "Business handled across the bay in both directions totaled 19,557 loaded cars. All records for a single craft were also broken during May, the tug *Delmar* having made 133 trips, each time with a float carrying 26 to 29 cars." The largest portion of freight handled was timber and forest products. (Cape Charles Historical Society.)

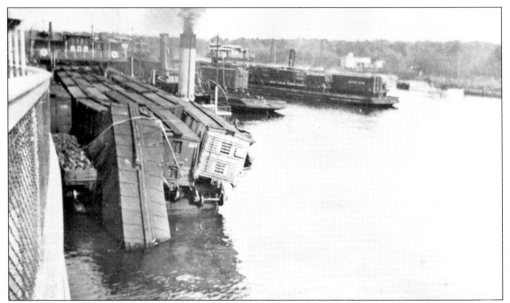

Rough weather only occasionally presented problems. In 1927, for example, a barge parted hawser with the tug *Delmar* in gale force winds on the bay and all cars were lost. In the mishap pictured above, the cars were pushed half overboard during a bay storm in 1930 but were brought safely into port at Cape Charles. (Cape Charles Historical Society.)

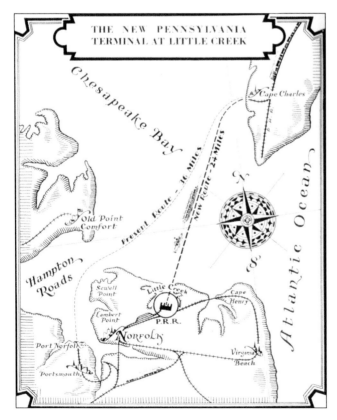

In 1929, the PRR moved to considerably reduce the distance of barge travel by opening a new train yard, the Little Creek Terminal in Norfolk. Earlier years had brought movement of the final destination for most cars from downtown Norfolk to the Port Norfolk rail yard in Portsmouth. This map from the program for the yard's opening ceremonies on January 10, 1929, shows a course of sail that would remove 12 miles from the journey. (Cape Charles Historical Society.)

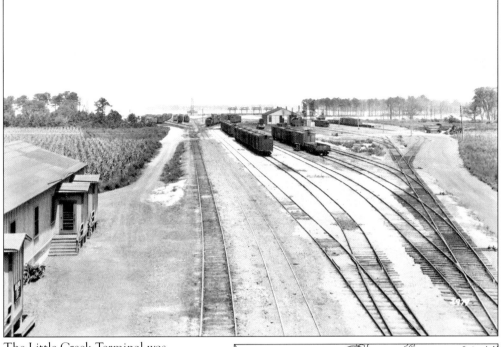

The Little Creek Terminal was located on an unpopulated inlet of the Chesapeake Bay and would come to share the site in later years with ships of the U.S. Navy. The yard was attached by direct line to the yards of other railroads heading south and west out of Hampton Roads. The map shows the presence within the region of the Chesapeake and Ohio, Seaboard Airline, Norfolk and Western, and other railroad companies. (Kirn Library, Sargeant Memorial Room.)

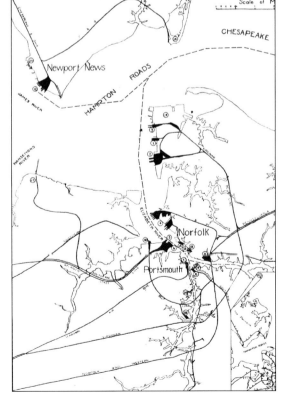

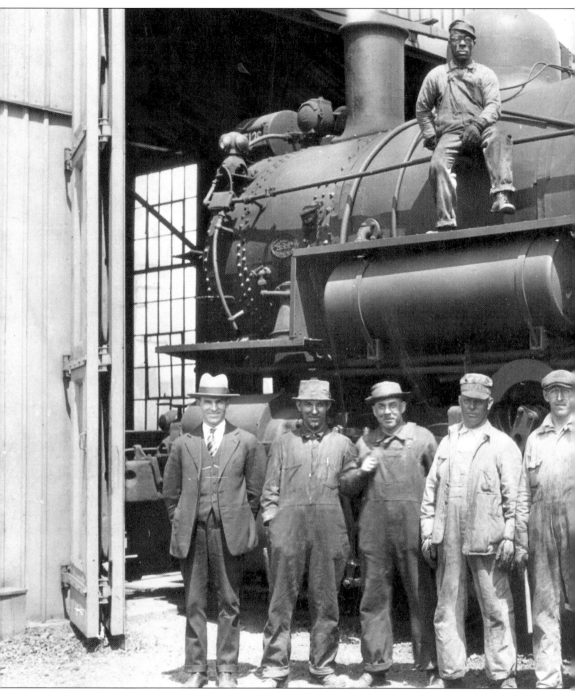

The engine house and car repair force is pictured at Little Creek on May 7, 1929. The foreman is identified as W. P. Rice (far left). This and other pictures of workers in the early 20th century show a railroad operation in the American South that generally followed the racial practices and attitudes of the full society. In the first years of the railroad, African American workers were generally classified as laborers, but as the 20th century progressed, different job categories for black and white workers evolved, in some cases along with separate unions for the two races.

In this picture, it is more than likely that the full group worked well together in a collegial way, although the African American worker was limited in what he could achieve. His position of being both part of and separated from the crew was accepted—though it may not have been acceptable—practice. The role of blacks in the railroad workforce followed the curve of American civil rights for the rest of the century. (Cape Charles Historical Society.)

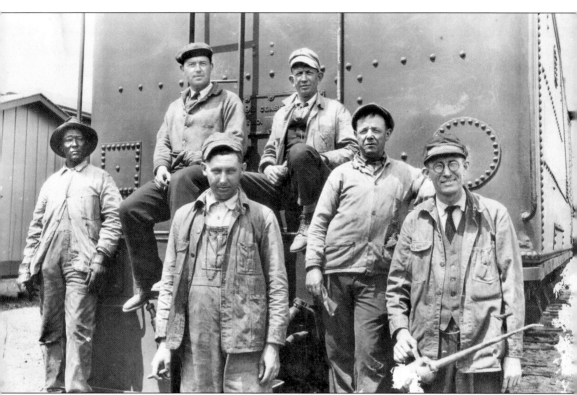

A shifting crew poses in the Little Creek yard on May 27, 1929. The foreman is identified as H. L. Blow (far right). The yard had been planned since 1916, as shippers on both sides of the bay looked for a way to reduce the time and distance required for crossing, particularly for perishables, which would still have a distance to go on other railroads. Developed at a cost of $5 million and opened to water traffic on January 3, 1929, it was seen as a historic development of railroading in Hampton Roads. (Cape Charles Historical Society.)

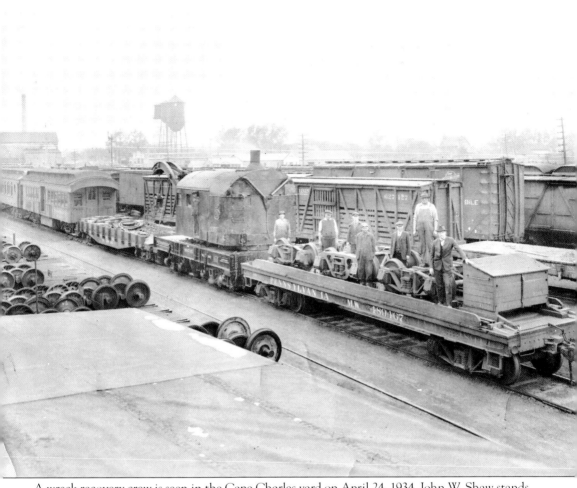

A wreck recovery crew is seen in the Cape Charles yard on April 24, 1934. John W. Shaw stands in the derrick cab; from left to right on the flat car are Jim Somers; Oscar Scott; unidentified; James Baker; Herman Moog, foreman of the car department; Sam Miles; and general foreman C. G. Brown. The picture offers a rich profile of the work at Cape Charles. The city's water tanks are in the distance, and smoke can be seen rising from the ice plant. Cattle cars were used to pick up livestock brought to pens located at various stations along the line. Passenger and freight cars are pictured along with a stock of replacement wheels and axles. Most train wrecks along the line required hard recovery effort by skilled workers. In the previous year, for example, three notable wrecks occurred. One on April 2, 1933, near Harrington, Delaware, involved a train that was carrying the entire Boston Red Sox baseball team. It had hit an open switch at 50 miles per hour. Only the engineer and fireman were killed. None of the Red Sox, traveling in Pullman cars at the end of the train, were injured. (Cape Charles Historical Society.)

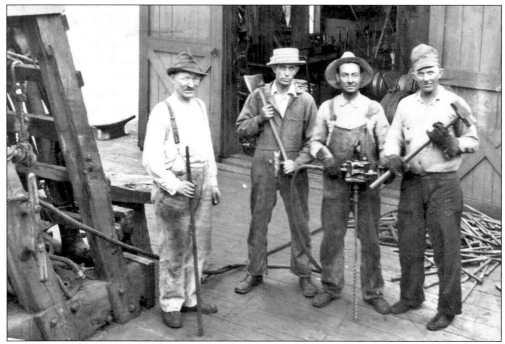

The water-bound environment in which the railroad operated required constant attention to the building, maintenance, and repair of bridges. The work was performed by piledrivers and their tools. Seen here c. 1920 are, from left to right, workers George Guy, John Robbins, Harvey Lewis, and Samuel Costing. (Cape Charles Historical Society.)

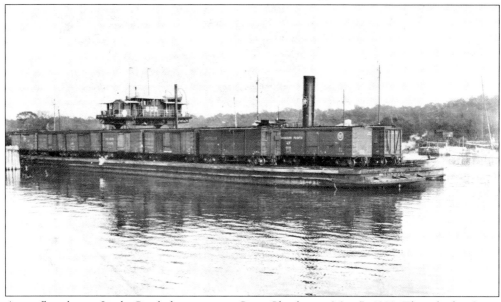

A car float leaves Little Creek for return to Cape Charles on May 7, 1929. Though the Great Depression was waiting around the corner, success of the shortened Little Creek run would grow into the 1930s. A new record was set on June 21, 1931, when 19 northbound barges carried 514 cars from Norfolk to Cape Charles at an average time per trip of 3 hours and 16 minutes. (Cape Charles Historical Society.)

Five

CAPE CHARLES AND THE FERRIES

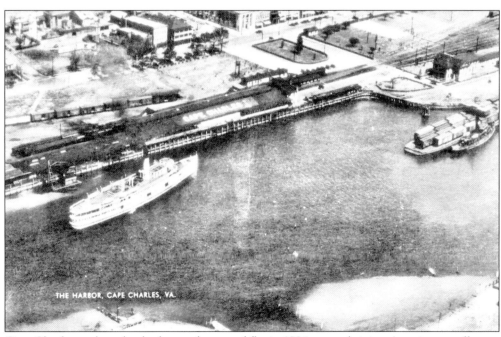

Cape Charles, a place that had started as a mud flat in 1884, was a thriving American small town by the 1920s. Of its 2,500 residents, approximately 500 worked directly for the railroad. As it was planned to be, it had become a unique intersection of land and sea, rail and ship, industry and agriculture, and the forces of rural and urban development. (Eastern Shore Railway Museum.)

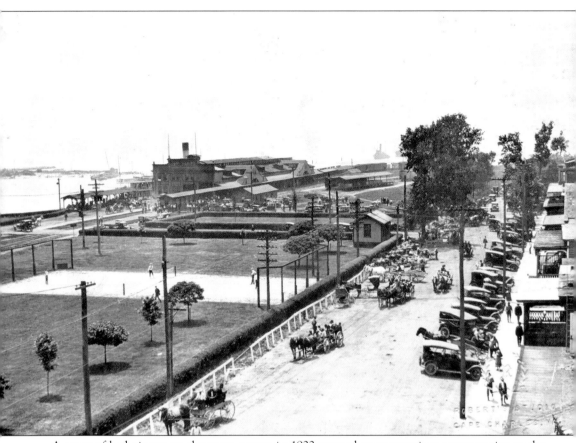

A game of badminton on the town square in 1922 seemed an appropriate counterpoint to the surrounding mix of horses, cars, boats, and trains at this point of transfer between land and sea. Mason Avenue, on the right, was the main commercial district, and the sheds of the rail and ferry station were full of travelers nearly around the clock. The town then owned its own water system. A newspaper, *the Northampton Times*, was published from the Times Building at Randolph Avenue and Strawberry Street. A new Ford automobile could be purchased from J. R. Leaman on Peach Street for $355 to $660, depending on the model, and a truck sold for $445. A housing boom was about to take place. Of the town's 2,517 residents in 1920, more than 350 were renters, and all lived in just 394 homes and hotels. (Cape Charles Historical Society.)

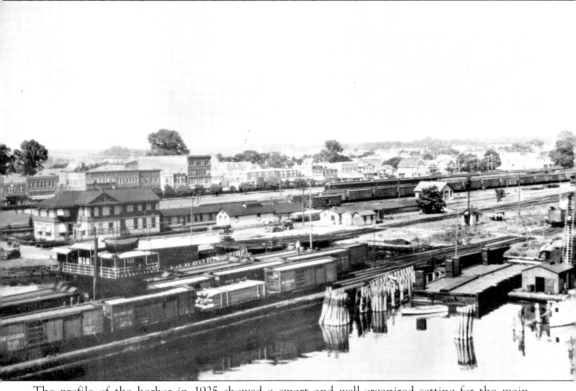

The profile of the harbor in 1925 showed a smart and well-organized setting for the main work of the town and its people. Some of the buildings on Mason Avenue behind the railroad station took on classic architectural themes. The Farmers and Merchants Trust Company was constructed of stone, brick, and concrete, with Ionic columns. A few years prior to this photograph, an inventory of NYP&N equipment reflected the strength of the railroad as seen here: 41 locomotives, 2,108 freight cars, 30 passenger cars, and 33 waterborne craft. (Cape Charles Historical Society.)

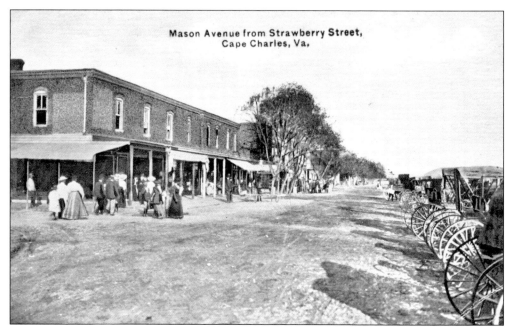

In 1910, Cape Charles was a town of 1,948 residents, and it would support 2,517 people by 1920. Streets were unpaved, though some sidewalks were made of brick, and oil lamps lit the streets. Electrification of streetlights would come in 1920, with power purchased from the railroad's generating facilities. (Cape Charles Historical Society.)

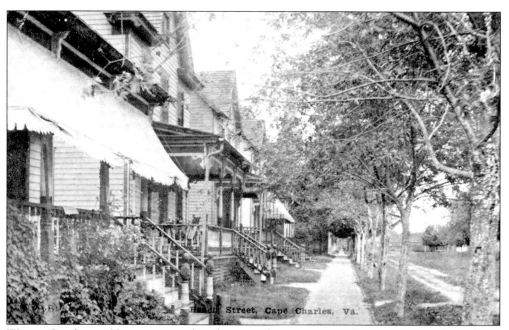

Warm Southern Virginia months from early spring to late autumn allowed an abundance of greenery to cover residential sidewalks, as on Peach Street in 1910. (Cape Charles Historical Society.)

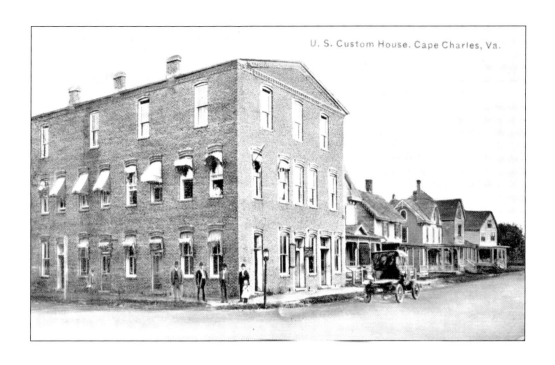

The U.S. Customs House and the Virginia Hotel, established in 1884 as the Tazewell Hotel, are seen in these in postcard views. At the beginning of the 20th century, housing for railroad workers was in particular demand. Three boarding houses charged from $16 to $18 monthly for room and meals. The Virginia and Arlington Hotels charged about $20 per month. A bath cost a quarter, payable in advance. (Cape Charles Historical Society.)

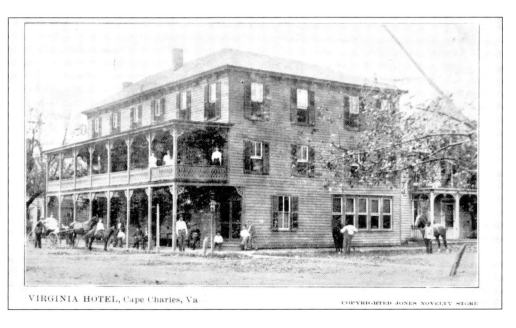

Away from the center of town, residential areas like Tazewell Street, seen at the turn of the century and in 1928, developed well-constructed homes and paved streets. The quality of architecture was determined, in part, by the sophistication that came to a very productive business community. A number of homes built during this time are believed to have been Sears and Roebuck kit homes, often found near the railroad lines that could easily deliver them. (Cape Charles Historical Society.)

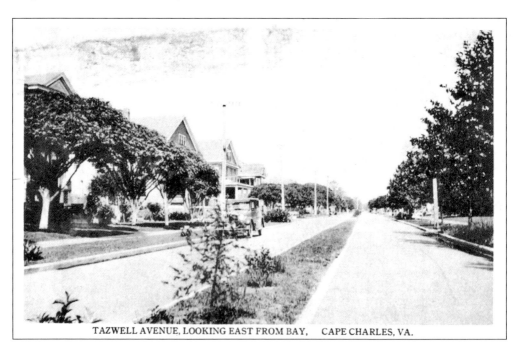

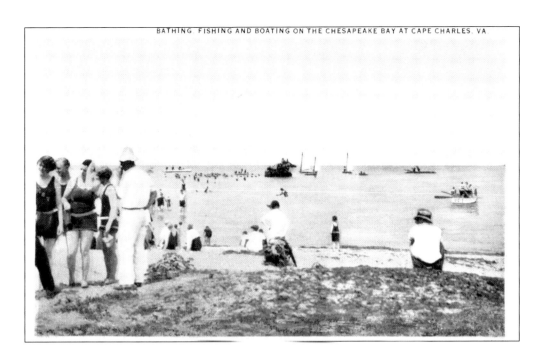

The main bathing beach was located, appropriately, on Bay Avenue on the Chesapeake Bay. The social nature of the town had always included the informal gathering of its people and those from surrounding farms downtown and on the beaches. The water was shallow far out, and the view of ferries and tugboats coming and going was enticing. Many of the large homes and mansions on Bay Avenue would stand into the 21st century and play a key role in the beginning of rebirth for Cape Charles at that time. (Cape Charles Historical Society.)

Here is an artist's rendition of Cape Charles at rest. Moonlight falling over the Chesapeake Bay and the Atlantic Ocean, just to the east, could be very bright. (Cape Charles Historical Society.)

A May Day celebration in 1923 was in keeping with the town's sense of public recreation and ceremony. Rotary Club meetings were held on board the ferries as they docked between runs; evening concerts were held outside in the summer months. In the 1930s, boxing matches were held on barges moored at the beachfront. (Cape Charles Historical Society.)

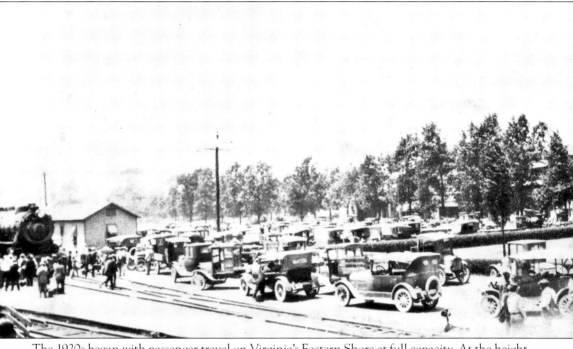

The 1920s began with passenger travel on Virginia's Eastern Shore at full capacity. At the height of the summer season—July 19, 1920, for example—2,679 passengers used the southbound trains and 2,241 the northbound trains. By steamer, 910 passengers traveled north and 1,995 traveled south. In 1920, six passenger trains arrived and departed Cape Charles daily, reduced to three on Sundays, a number of them express trains to New York. It was expected that passenger journeys would be pleasant and in some ways elegant. Food and dining were important, and at the height of its passenger operation, the PRR published a comprehensive 120-page book for its dining-car employees. It include a one-page history of cooking: "The culinary art was considered not only from the standpoint of nourishment and enjoyment, but as a means to evolve scientifically a finer physical instrument for the manifestation of higher intellectual powers." The book went on to give very precise recipes and instructions, ranging from portion sizes of meats to the varied contents of breadbaskets. (Cape Charles Historical Society.)

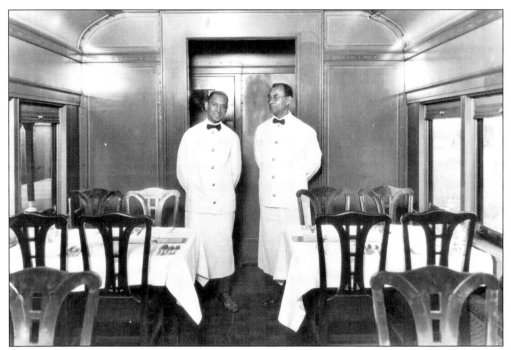

Staff waited to fulfill the precepts of the PRR dining philosophy, as in this car at Cape Charles, and in 1920, the operation and supply of rail and steamer dining facilities was moved to Cape Charles from Norfolk. The chef of Dining Car No. 1106, Train No. 454 from Cape Charles to Philadelphia, was famous for his pies. (Cape Charles Historical Society.)

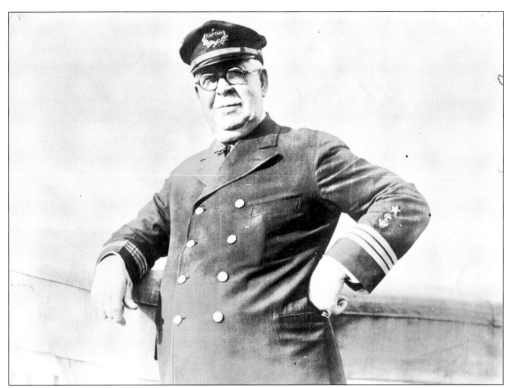

Another famous railroad employee was Robert Maguire, who started as a deck hand on the first NYP&N steamer in 1884 and went on to become senior passenger captain of the popular Cape Charles–Norfolk passage. The portrait is dated April 25, 1924. (Cape Charles Historical Society.)

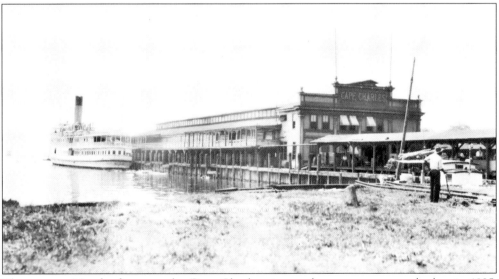

The steamer *Maryland* rests at the Cape Charles pier, ready to return across the bay in 1925. The *Maryland* was 250 feet in length with a 40-foot beam. Built in 1906 by the Maryland Steel Company, she was the last boat built for the NYP&N before it was taken over by the PRR. The *Maryland* worked the waters between Norfolk and Cape Charles until her retirement in 1949. She was dismantled in Bordentown, New Jersey, in 1950. (Cape Charles Historical Society.)

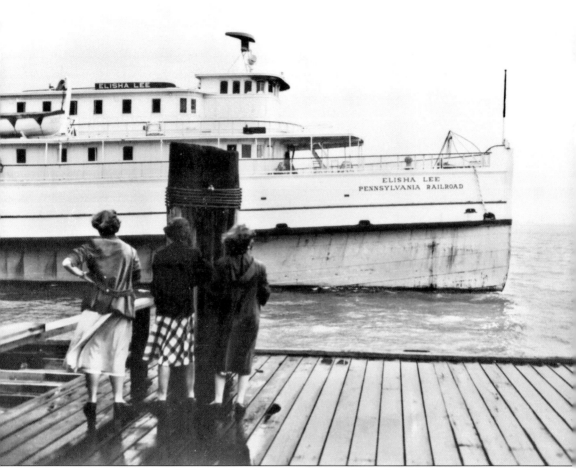

Among the most beloved of the railroad steamers was the *Elisha Lee*. Her history was typical of many of the bay steamers of the early 20th century. Built in 1892 for the New Haven Steamboat Company as the *Richard Peck*, she ran a regular route on Long Island Sound between New York and New Haven. She was commissioned by the U.S. Navy in 1941 for use in Newfoundland and returned to service for the PRR in March 1944. Renamed after a popular former NYP&N supervisor at Cape Charles as the *Elisha Lee*, she transported record numbers of passengers between Norfolk and Cape Charles until her last run in 1953. Symbolic in many ways of the history and nature of the railroad passenger ferries on the bay, her last run would be the last passenger run for any of the passenger ferries out of Cape Charles, though others would continue to run from a new location at Kiptopeke. She was dismantled in Baltimore in 1953. (Courtesy of Robert Lewis.)

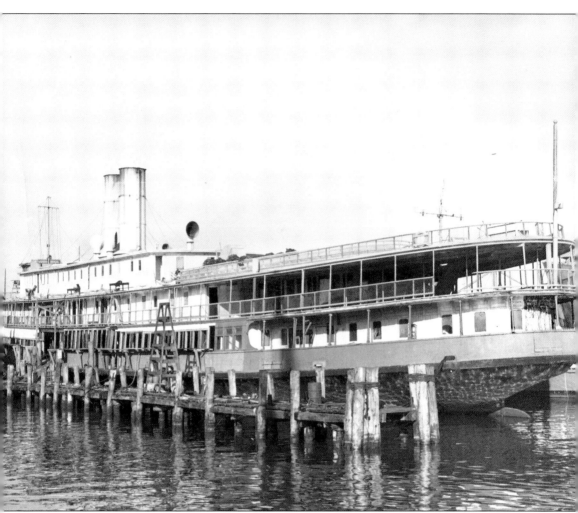

Shown here after service in the war and before conversion to the *Elisha Lee*, the *Richard Peck* was considered to be one of the classic American steamships. She was designed for Harlan and Hollingsworth Ship Builders of Wilmington, Delaware, by the famous late-19th-century American marine artist Archibald Cary Smith. Smith was a painter of dramatic yacht scenes, many suggesting a frightening immensity to the sea. As a yacht designer, his work included the 1881 America's Cup defender *Mischief*. Harlan and Hollingsworth promotional material on the *Richard Peck* described her as "one of the speediest passenger vessels afloat. Beautiful cabins, large and well-furnished staterooms, excellent freight space and all modern improvements and conveniences make this boat an ideal vessel for the business engaged in. Speed over 20 miles an hour." (Cape Charles Historical Society.)

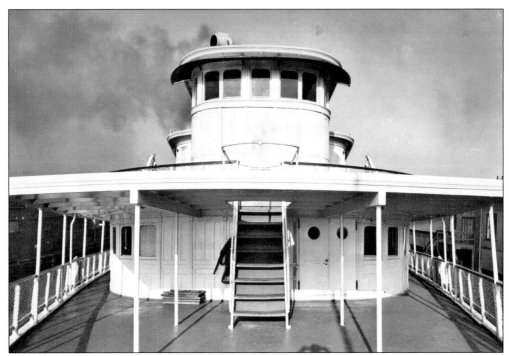

The deck and dining room of the *Elisha Lee* are photographed March 5, 1944. With two triple-expansion steam engines, she was one of the fastest ferries on the lower Chesapeake Bay. At 303 feet in length, she could accommodate 1,200 passengers, and with her entrance to service on a route that was increasingly carrying passenger automobiles, she was refurbished to gain a capacity of 75 motor vehicles. (Cape Charles Historical Society.)

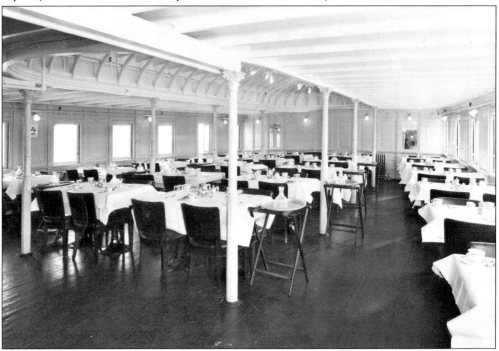

Food service and dining were as important on the ferries as on the trains, with a larger opportunity for well-cooked meals served at comfortable tables. The dining menu for the *Virginia Lee* in 1931 suggested that dining at sea could include the best grace notes of wine, mineral waters, and cigars. It also offered a full reading of schedules and tolls for the crossing. (Cape Charles Historical Society.)

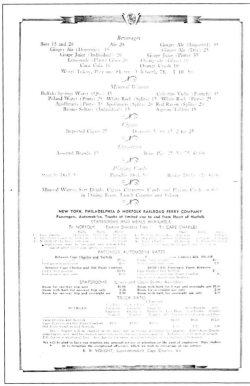

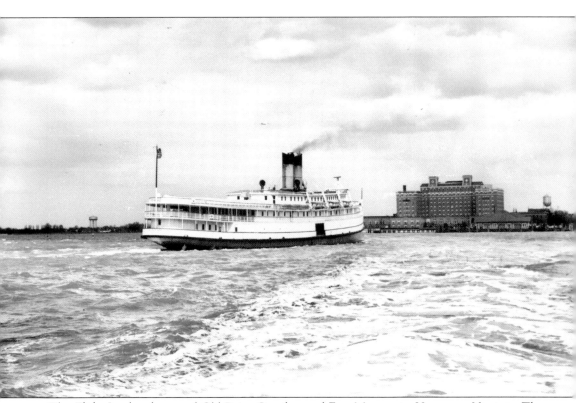

The *Elisha Lee* heads toward Old Point Comfort and Fort Monroe in Hampton, Virginia. The hotel rising above the bay is the Chamberlin, built in 1887 and rebuilt after a fire in 1928. During World War II, the hotel's towers were removed by military order because they could be seen from a distance 20 miles east in the Atlantic and might help to target attacks on the military facilities around the lower bay. As a sheltering harbor, Old Point Comfort had been named Cape Comfort by the Jamestown colonists of 1607 and became a place of bay fortification in 1609. Its Fort Monroe, completed in 1834, was surrounded by a moat and used by Union forces in the Civil War, then later by the U.S. Army. Old Point Comfort continued as a popular seaside resort and ferry destination into the 20th century. Fort Monroe and the Chamberlin Hotel stood into the 21st century, but Fort Monroe would be scheduled for full closure by 2011. (Courtesy of Robert Lewis.)

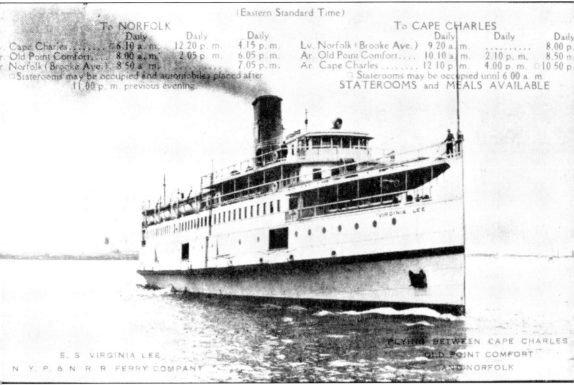

The NYP&N steamer *Virginia Lee* was the last vessel built for the Norfolk run and was named for the daughter of Elisha Lee. In 1942, she was requisitioned by the U.S. Navy and turned over to the British to be used in the war effort, but when she arrived in convoy at St. Johns, Newfoundland, her easily frozen pipes made her unfit for duty. Instead she was sent to the Amazon River to work in the rubber trade as a transport for engineers and native workers. Eventually she was returned to work in the United States on the Boston-Provincetown ferry line under the name *Holiday*. Returned to the Chesapeake Bay run as the *Accomac* in 1956, she eventually burned while under repair and was abandoned on the Potomac River near Quantico, Virginia, as of 2003. (Cape Charles Historical Society.)

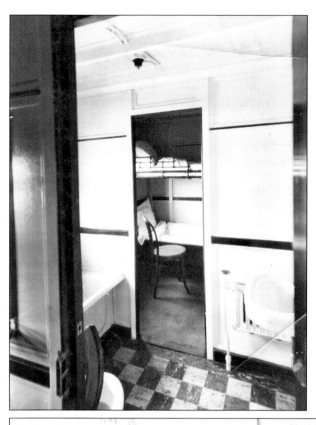

Private quarters were available on some of the ferries. The *Virginia Lee* had carried passengers for various purposes on routes in New England and was not without its individual comforts, like the private cabins shown at left. For the most part, travel on the Cape Charles–Norfolk route was inexpensive and simply accomplished. The Peninsula Ferry Corporation was an operation in competition with the PRR ferries from 1930 until it was absorbed by the PRR in 1933. (Cape Charles Historical Society.)

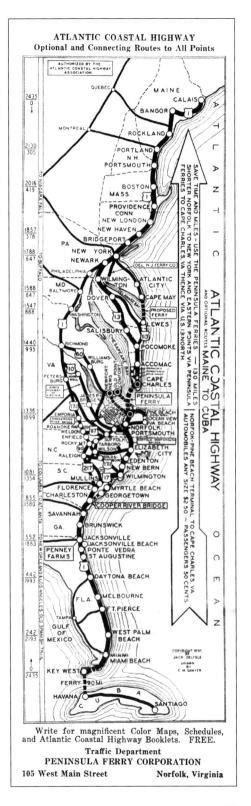

The 1938 Peninsula Ferry Corporation schedule unfolded here includes a map to suggest that it might be possible to drive from Calais, Maine, to Havana, Cuba, by using the Chesapeake Bay crossing. At that time, ferry service was available from Key West to Havana, operated by the West India Fruit and Steamship Company. The SS *Havana* was advertised as fully air-conditioned and with splendid accommodations for 500 passengers and 123 automobiles. The map also shows a proposed ferry service from Cape May, New Jersey, to Lewes, Delaware. That service did not actually begin until 1964, coincidentally with the run of the last ferry in the lower Chesapeake Bay at that time. No longer needed in the bay, some of them were moved up to the Delaware bay for the new service there. The New Jersey–Delaware ferry continued operation into the 21st century. (Cape Charles Historical Society.)

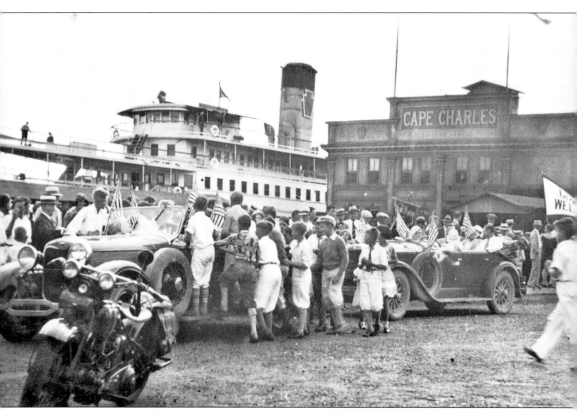

At the start of the Depression, businessmen and politicians at both ends of the ferry route between Norfolk and Cape Charles tried to take advantage of their transportation connections to develop the economy of the region. On September 11, 1930, Virginia governor John Pollard and 400 businessmen traveled ceremoniously to Cape Charles on the PRR steamer *Virginia Lee*, where they were met by an even larger number of Shore residents. A mock burial was performed, of which the governor said "caskets containing Old Man Business Depression, his wife Mrs. Pessimism and his daughter Miss Misfortune will be consigned to a watery grave in the Chesapeake." The Depression took its inevitable toll on Cape Charles, however. Its population in 1930 was 2,527, then 2,299 in 1940. It was not able to return to its largest size during the rest of the 20th century and entered the 21st with an estimated 1,134 people. (Cape Charles Historical Society.)

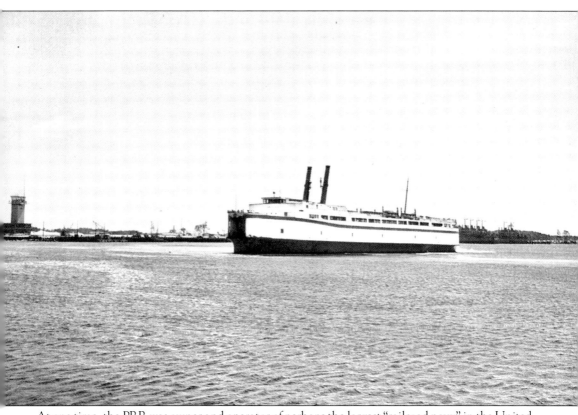

At one time, the PRR was owner and operator of perhaps the largest "railroad navy" in the United States. Its fleet of tugs, barges, and ferries in New York harbor was complemented by extensive marine operations in Philadelphia. In 1933, the PRR placed its Virginia ferry operations under a subsidiary, the Virginia Ferry Corporation (VFC). Newly designed ferries were put into service to better accommodate passenger automobiles and growing numbers of trucks. The *Delmarva* was launched by the VFC on November 2, 1933. Built at a cost of $600,000, her 13-foot clearance and double doors at either end accommodated any kind of vehicle. Steam uniflow engines could develop 3,100 horsepower and carry 1,200 passengers and 90 automobiles at 18 miles per hour. (Courtesy of Robert Lewis.)

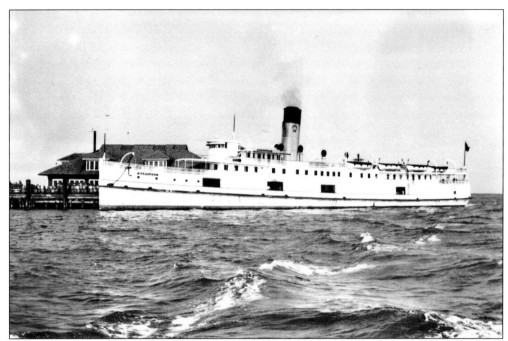

The steamer *Maryland*, shown here at Old Point Comfort in 1946, became a running mate across the bay with the *Delmarva*. By the summer of 1934, they had combined their effort to make seven daily round-trips, but by 1949, passenger traffic had declined enough that the *Maryland* was retired from service. (Cape Charles Historical Society.)

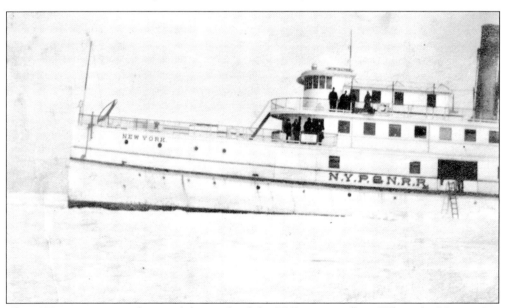

The 1930s were a time of renewal for much of the PRR steamer fleet. When the *Virginia Lee* entered service in 1928, it replaced the *New York*, shown here as photographed by its crew while stuck in rare ice on the bay. Though winter snow and ice could come easily to the northern reaches of the Chesapeake Bay in Maryland, they were rare occurrences over the bay waters of Virginia. (Cape Charles Historical Society.)

Six

WORLD WAR II AND THE AUTOMOBILE

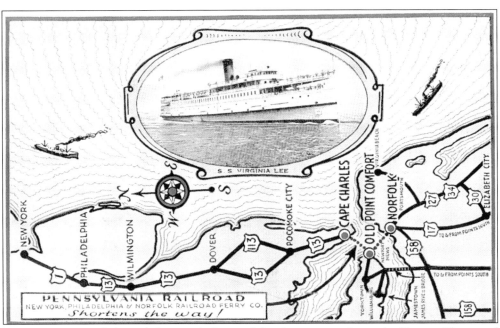

In 1940, a postcard showed the simple logic of the direct route down the Eastern Shore and began to predict the competition presented to the railroad by U.S. Route 13. During the years of World War II, however, the railroad operated almost beyond its capacity. Its southern terminus in Norfolk was the center of troop embarkation for all military services. Troop trains moved personnel in and out of the area, and often the trains could be seen backed up for miles out of Cape Charles, waiting to move their passengers across the water to Norfolk. (Courtesy of Robert Lewis.)

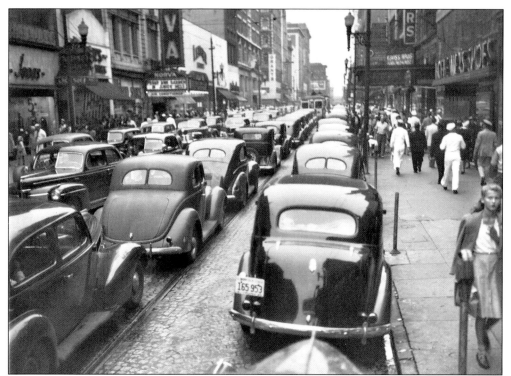

Sailors are among the crowds on Granby Street at the center of downtown Norfolk on VJ Day, August 15, 1945. The date also marked the end of gasoline rationing that had restricted automobile use. As seen, with those restrictions lifted, cars were ready to change the nature of American transportation, with damaging future results for the PRR and especially its work on Virginia's Eastern Shore. (Kirn Library, Sargeant Memorial Room.)

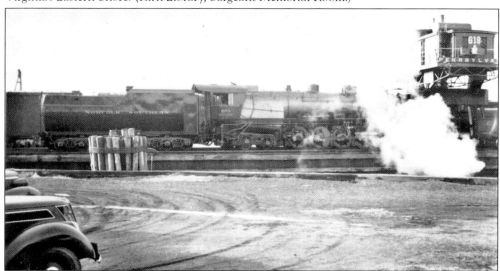

In a rare picture, a Norfolk Southern locomotive is seen loading a PRR barge at Little Creek in the 1940s. The Norfolk Southern extended the reach of the PRR into North Carolina, just to the south of Little Creek. The railroad was merged into the Southern Railway in 1974, which, in turn, merged with the Norfolk and Western Railway in 1989. (Cape Charles Historical Society.)

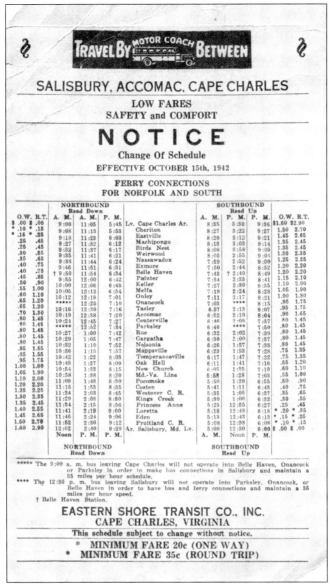

The transportation demands of the war and the improvement of highways had led to the development of alternative methods of travel, while wearing down the physical condition of trains and boats that had supported the war effort. Improvements on U.S. Route 13, which paralleled much of the railroad right-of-way on the Delmarva Peninsula, led to competitive passenger bus service. Like the railroads, bus companies were always evolving through new names, route structures, operators, and owners. The Eastern Shore Transit Company would eventually become part of a national system. Incorporated in 1926, it was sold to the Carolina Coach Company in 1952. Carolina Coach became Carolina Trailways, and when Greyhound absorbed the national Trailways lines in 1997, Carolina Trailways retained its own name as a Greyhound subsidiary. In the early 21st century, the same bus route through the Virginian Eastern Shore was covered by through bus service between Norfolk and New York City. The trip took from 8 to 10 hours on Carolina Trailways, though with very few scheduled stops along the way. (Cape Charles Historical Society.)

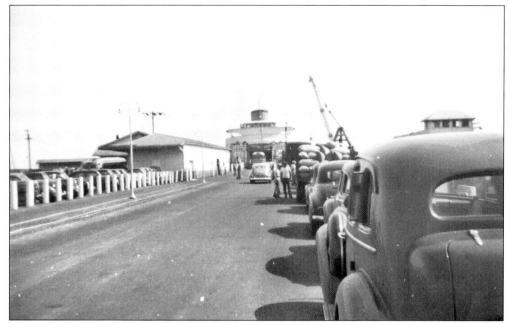

By 1946, the automobiles and buses that competed with the passenger business of the PRR made increasing use of the VFC ferries and those of other companies as connections between highways. At the Little Creek terminal, modern buses of the time could be seen emerging from the vehicle deck of the VFC's steamer *Princess Anne*, while cars wait in long lines for the return trip. (Courtesy of Robert Lewis.)

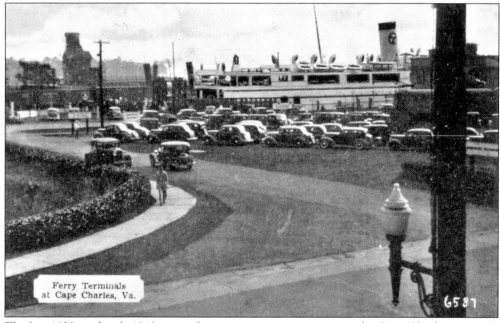

The late 1930s and early 1940s saw a dramatic increase in activity at the Cape Charles terminal, including regular walk-on traffic of Eastern Shore residents going round-trip to Norfolk. In 1944, the steamers *Maryland* and *Elisha Lee* combined carried 1,104,600 passengers. (Cape Charles Historical Society.)

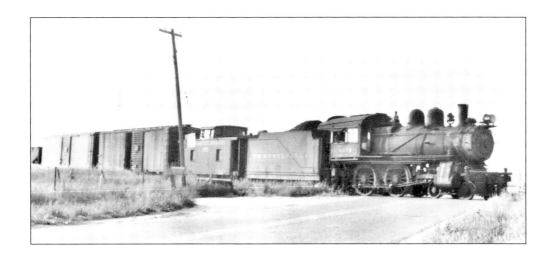

Also feeding into the system's mix of freight and passengers were the small roads that crisscrossed the line, especially in Maryland and Delaware. Here the Queen Anne's Railroad runs a small freight train in 1950 that will cross Salisbury on the Baltimore, Chesapeake and Atlantic right-of-way. The Queen Anne's was formed in Maryland and Delaware in 1894–1895 as a line that would run from a Baltimore steamer connection at Queenstown, Maryland, to a terminus on the Atlantic coast at Lewes, Delaware. At Lewes, passengers could make rail connections to Delaware resorts through Rehoboth (shown below in 1917) and steamer connections to Cape May, New Jersey. (Courtesy of Robert Lewis.)

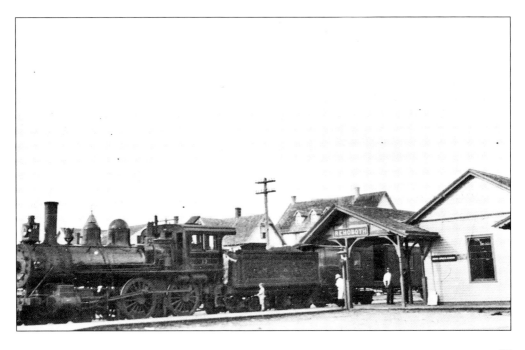

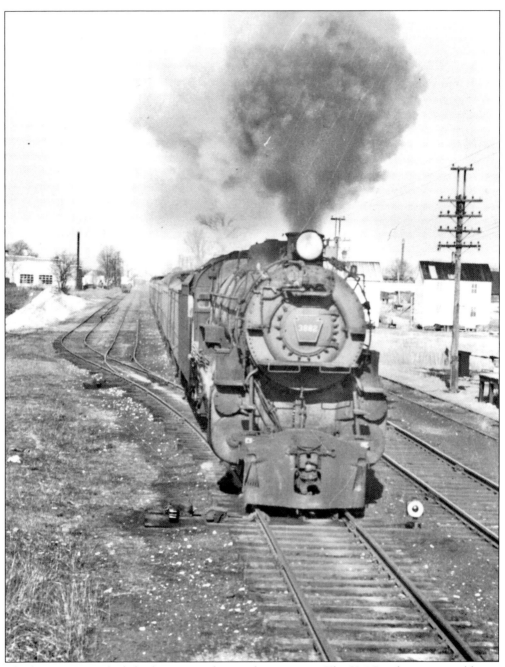

The late 1940s marked the last years of steam locomotives. The K-4 Pacific was a workhorse of the PRR. It used 80-inch drivers and 205 pounds of pressure, weighed 308,890 pounds, held 7,000 gallons of water, and carried 12-and-a-half tons of coal. It could pull 16 cars easily and reach high speeds, with a record for the K-4 set at 93 miles per hour. It is seen here pulling out of Salisbury, Maryland, for a run to Cape Charles in 1948. (Eastern Shore Railway Museum.)

Travel down the Eastern Shore of Virginia was often within 50 feet of U.S. Route 13 on the west side of the track and passed factories and warehouses just to the east. U.S. Route 13 had its origins north of Philadelphia and took over the path of Virginia Route 34 in 1927. In 1951, its endpoint was diverted from Cape Charles to Kiptopeke State Park. When the Chesapeake Bay Bridge Tunnel was opened in 1964, it continued into Norfolk without interruption. (Eastern Shore of Virginia Historical Society.)

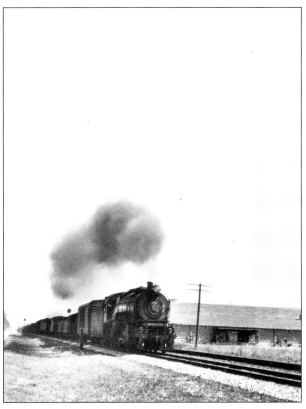

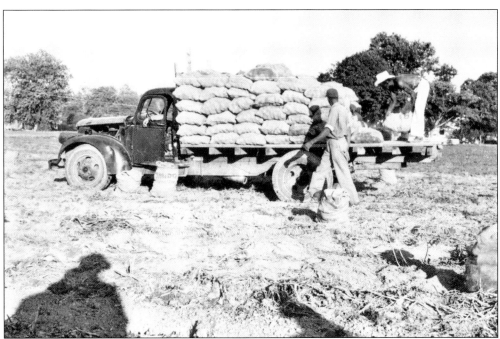

Potatoes remained a major crop for the Eastern Shore well into the 1940s. (Eastern Shore of Virginia Historical Society.)

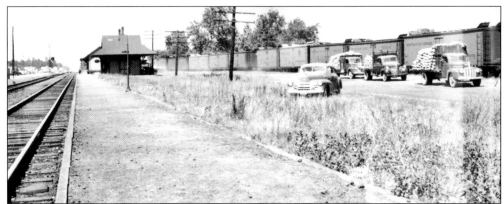

Potatoes are loaded into refrigerator cars at Keller Station for shipment north and south in 1946. "Reefers" were often not owned by the companies on whose lines they traveled. Those in this picture are labeled "Western Fruit Express," a company that was formed by the Fruit Growers Express (formerly a subsidiary of Armour Meats) and the Great Northern Railway in 1923. (Courtesy of Robert Lewis.)

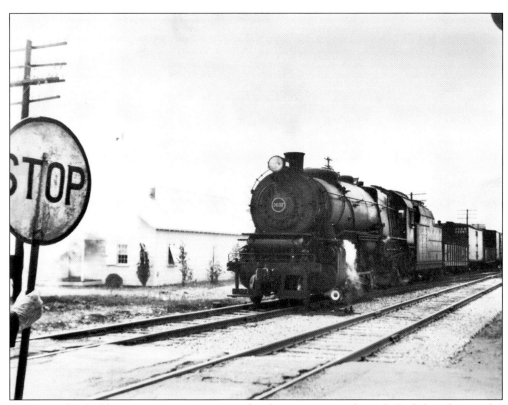

Here a worker holds a crossing stop sign as a freight train passes through Parksley, three miles west of U.S. Route 13, in 1946. Designed to grow with development of the railroad, Parksley was a center of Eastern Shore commerce well into the 20th century. It exported the abundant agriculture of the Shore and imported fertilizers, coal, building supplies, and consumer products. (Eastern Shore of Virginia Historical Society.)

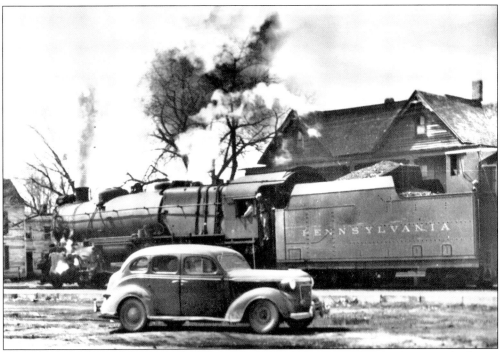

The train above has stopped at the station in Parksley before moving out of town under heavy steam. The site is the current location of the Eastern Shore Railway Museum. The Parksley station pictured here no longer exists; it was replaced on the museum site with the station that had originally served the town of Hopeton. Other buildings on the museum site are original to the location. (Eastern Shore of Virginia Historical Society.)

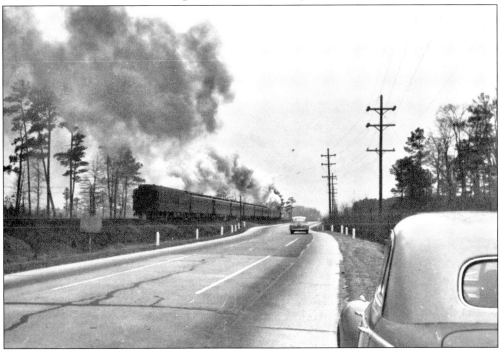

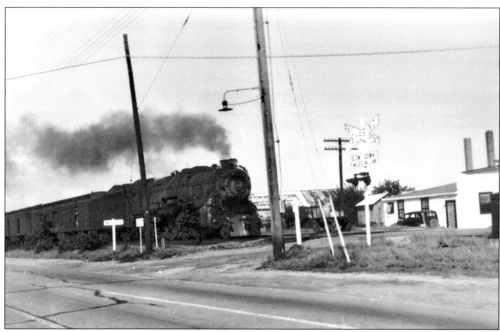

The train returns within touching distance of U.S. Route 13 and passes through Nassawadox. Named for the Nusswatok Indians, the town was an active Quaker community in Colonial America. (Eastern Shore of Virginia Historical Society.)

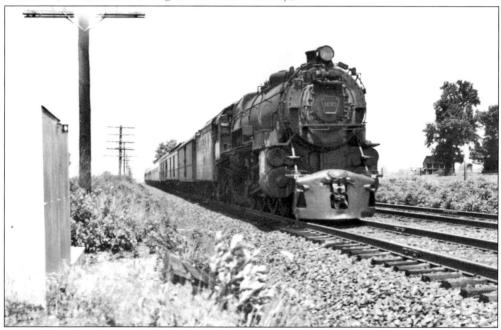

Though the small Virginia towns often seemed unattractive where they were crossed by the railroad, the farmland in between was often lush with produce, as in the summer of 1947. From the first years of agriculture in the 17th century and into the 21st, the Eastern Shore's temperate climate, fed by winds from the nearby bay and ocean, has allowed it to serve as a generous supplier of food to the nation. (Courtesy of Robert Lewis.)

Seven
AT WATER'S EDGE

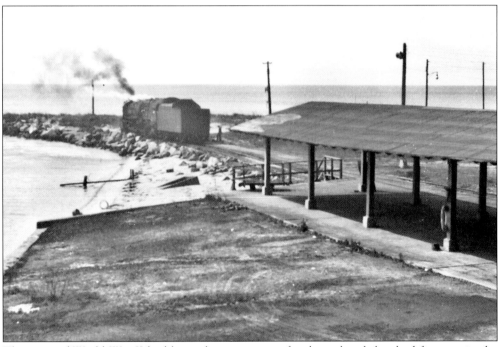

The years of World War II had been the most active for the railroad that had first run in the 1880s, but the end of the war was the beginning of a new era. In 1954, this southbound passenger train sits at its final stop, a dead end at water's edge. A steamer to Norfolk has already left its pier, and the locomotive waits to be backed up into the rail yard. The lonely locomotive at the end of its line seemed to tell the story of changing times. In 1950, four daily trains had been dropped from the schedule, and 6 of the 14 stations on Virginia's Eastern Shore had been closed. More reductions followed, and in 1954, the railroad went to a single-track system. Removal of the northbound track between Cape Charles and Pocomoke was begun on August 24 of that year. The efficiencies of diesel locomotion were cited as a reason that the track could be shut down. (Courtesy of Robert Lewis.)

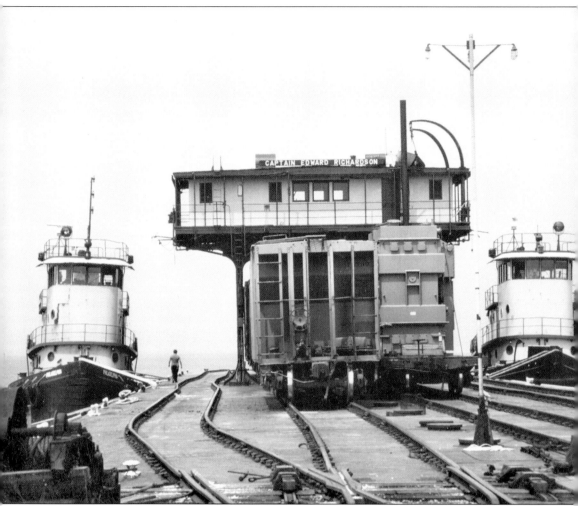

For the freight cars at the water's edge, there was still a distance to go. The barge *Capt. Edward Richardson*, named in memory of a former PRR mariner, was put into service on January 7, 1949. The largest of the barges to date, she was 407 feet in length and 51 feet abeam and could carry 32 cars on four tracks, attended by a crew of five. On this trip, it would use two tugboats abreast. The tug *Philadelphia*, left, was the second of that name in the railroad's history. The first was a 350-horsepower craft of the 1920s. This version was a 1,600-horsepower diesel 13 feet long and weighing 292 gross tons. (Eastern Shore Railway Museum.)

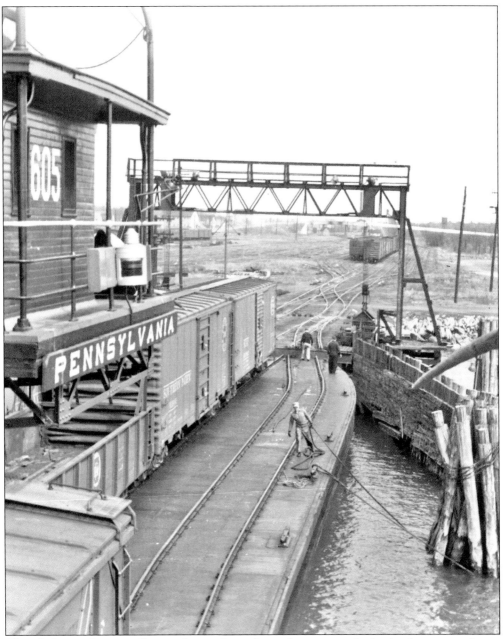

Though designed to stay afloat in the roughest of seas, there was no doubt that barges were heavy machinery requiring precision movement and heavy muscle. (Eastern Shore Railway Museum.)

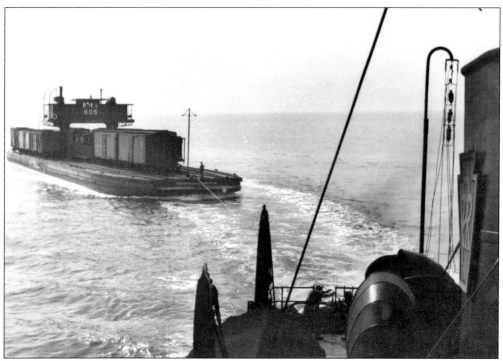

Pulled across the Chesapeake Bay and 1,000 feet behind the tugs that moved them, the barges became silent, moving islands and a perch for the birds of the water. As the 1950s progressed, fewer of these trips were made and averaged 400 cars per day at one point, less than half the daily average of a decade earlier. (Eastern Shore Railway Museum.)

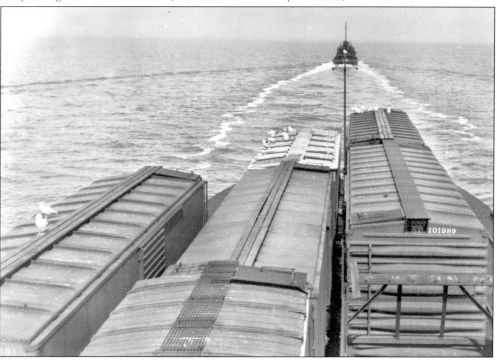

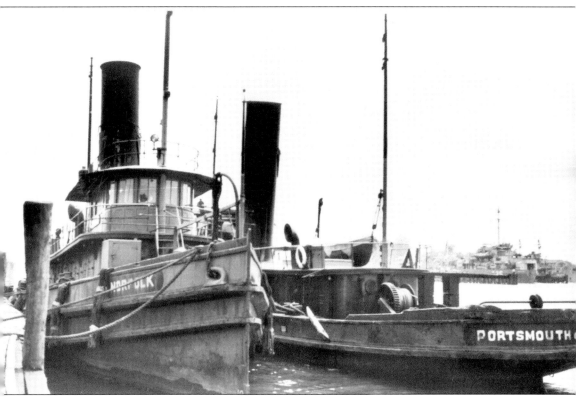
Tugs rest at the Little Creek piers in 1946. The war had seen the rapid development of U.S. Naval facilities at the mouth of the Chesapeake Bay, and ships of the Naval Amphibious Base at Little Creek can be seen in the background. (Courtesy of Robert Lewis.)

The rail port in downtown Norfolk is seen in 1955. The original Norfolk docks of the NYP&N were used by other railroads into the second half of the 20th century. The elevated black tank between the tracks dates back to the molasses trade with the West Indies in Colonial times. The Elizabeth River heads north to the Chesapeake Bay, right, and the Portsmouth waterfront sits across the river. This was mainly a rail operation of the Chesapeake and Ohio Railroad (C&O). The original NYP&N–C&O passenger station can be seen in part at the left edge of the frame, no longer in use. By the 1970s, this was empty property stripped of any vestiges of railroad use. In the 1980s, it became prime property for luxury condominiums that would be built into the next century. (Kirn Library, Sargeant Memorial Room.)

In the 1940s and 1950s, Norfolk's Water Street was still shared by freight cars that were moved from the downtown port to connections with other rail lines. They sometimes had to squeeze by parked cars in deserted sections and fed warehouse and truck depots along the way. (Kirn Library, Sargeant Memorial Room.)

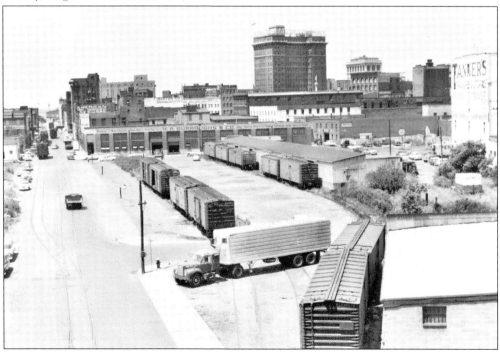

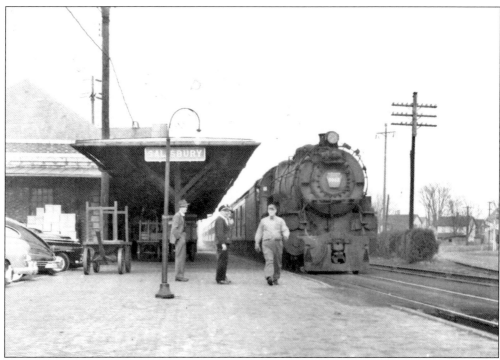

While freight and passenger loads on the railroad were in decline, steam locomotives were being replaced by diesel. These are believed to be among the last and first runs of each on the Delmarva line. The last steam locomotive for hauling of freight would be phased out of the system in 1957. (Eastern Shore Railway Museum.)

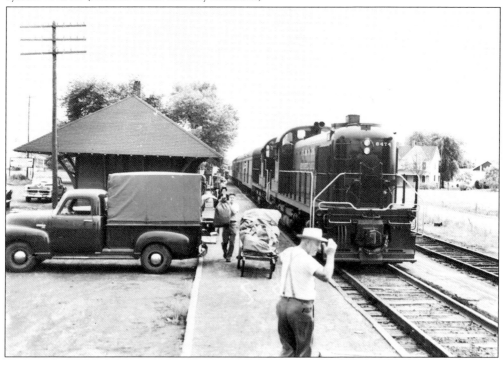

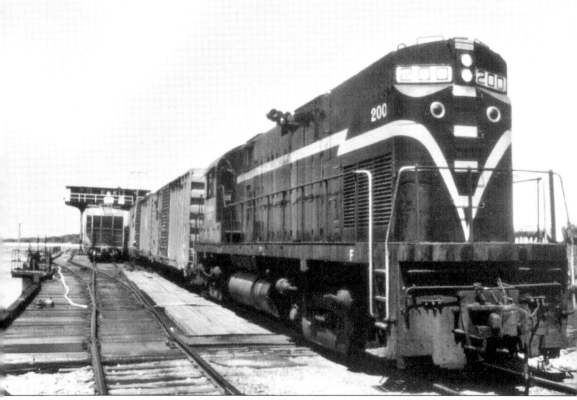

This American Locomotive Company (ALCO) C 420 was built for the Long Island Railroad (LIRR) in the early 1960s. LIRR engineers were not fond of the ALCOs and complained that they were overly dirty and noisy. Under the insignia of the Virginia and Maryland Railroad that was to be formed from the original NYP&N in the late 1970s, No. 200 loads freight cars for barge transfer to Little Cree. The method used for barge loading was often to place empty cars between the locomotive and the cars to be loaded so that the locomotive could stay close to land-bound. (Eastern Shore Railway Museum.)

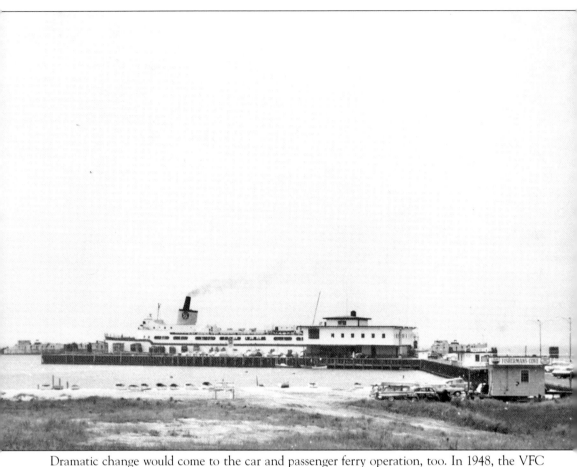

Dramatic change would come to the car and passenger ferry operation, too. In 1948, the VFC purchased 300 acres of beach property for $90,000 at Kiptopeke, eight miles south of Cape Charles. Route 13 was extended eight miles to reach a toll plaza that gave access to the ferry terminal. Kiptopeke was an Indian word meaning "Big Water," and the site was named in honor of the younger brother of a king of the Accawmak Indians who had been friendly to early settlers in the area. After ferry service was ended from this site in the 1960s, it became a state park and retained its nature as a stopover for migrating birds. Kiptopeke's hawk observatory is one of the most active nationwide. (Eastern Shore of Virginia Historical Society.)

Official Guest Card for the Dedication and Opening of

The VIRGINIA FERRY CORPORATION'S
New Eastern Shore Terminal
KIPTOPEKE BEACH, VIRGINIA

Saturday, April 29, 1950

Dedication - 12:00 Noon

This card will admit bearer to dedication opening.

A new terminal, opened May 1, 1950, would reduce the length of the water crossing by 20 minutes. The pier was 200 feet wide and extended 1,800 feet into the bay. At a cost of $2.75 million, it was promoted as the world's largest and most modern ferry pier. It was rebuilt as a fishing and boating pier for general public access in 1999. (Cape Charles Historical Society.)

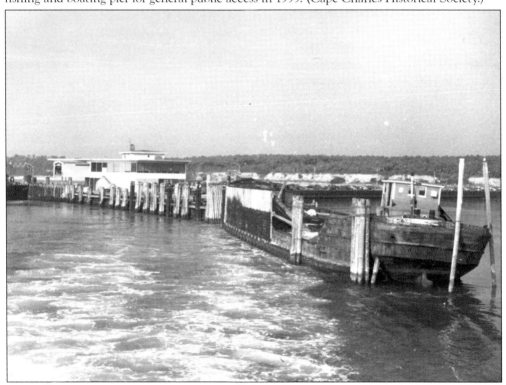

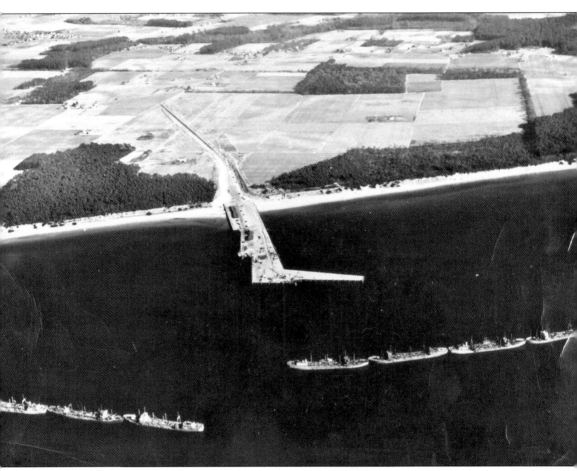

An aerial view of the Kiptopeke pier shows a curious breakwater set out in the bay. In the steel shortages of World War II, the U.S. Maritime Commission had contracted the McCloskey Company of Philadelphia to build 24 ships made of reinforced concrete. Concrete ships had been constructed for World War I but were not used by the time the war had ended. Concrete technology in the 1940s allowed for ships that were strong and remarkably buoyant. Most were built in Tampa, Florida, beginning in July 1943 at the rate of one each month. Two of the ships were purposely sunk as blockships in the Allied invasion at Normandy. At war's end, those in surplus made effective breakwaters for ports around America, including those seen here. (Courtesy of Robert Lewis.)

Change was marked, too, by the disappearance of the aging passenger steamers that had traveled between Cape Charles and Norfolk for much of the century. The *Pennsylvania* and *Maryland* were sold for scrap in 1950. Of the classic steamers, only the *Elisha Lee* was left to run from Cape Charles to Norfolk, but not for much longer. (Eastern Shore of Virginia Historical Society.)

When the *Elisha Lee* took its last run on February 28, 1953, the trip was considered a loss for Chesapeake Bay transportation. The ship was expected to fail a rigorous Coast Guard inspection scheduled for the following day. As she left Cape Charles for the last time, her whistle cord was tied down so that it would blast for five minutes, and other vessels returned the blast in respect. Coast Guard inspection revealed the need for $600,000 in repairs and upgrades. She was sold for scrap at $19,000. (Eastern Shore Railway Museum.)

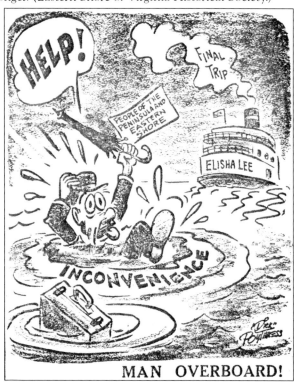

Ferries between Kiptopeke and Norfolk took on different configurations and were in heavy demand as auto, truck, and bus haulers. In 1954, four VFC ferries were running continuously, but they were reconstructed versions of older vessels. The *Princess Anne*, seen here approaching Kiptopeke, was first built in 1938. In 1954, she was cut in half and a 90-foot extension was added amidships. (Top: Courtesy of Robert Lewis; bottom: Cape Charles Historical Society.)

The *Princess Anne* is seen at the pier and in an interior view in 1950. The reconstructed ferries often ran continuously without being able to keep up with demand. Quality of service suffered as the VFC tried to adapt to demand, and in response to complaints, the Virginia General Assembly created the Chesapeake Bay Ferry Commission in 1954, which acquired the VFC in 1957. (Top: Cape Charles Historical Society; bottom: Courtesy of Robert Lewis.)

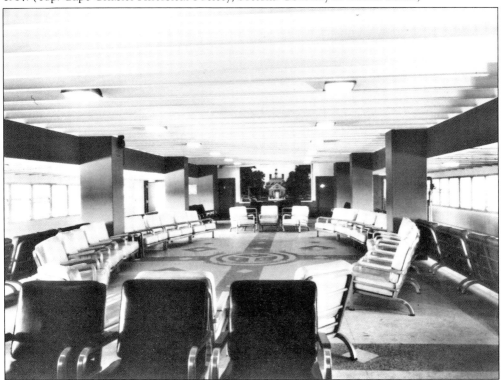

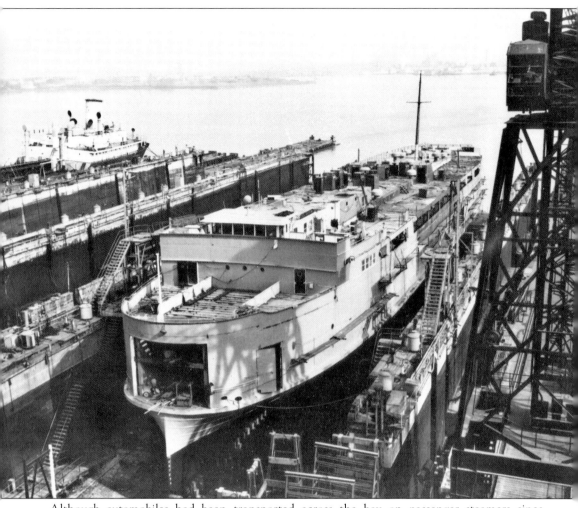

Although automobiles had been transported across the bay on passenger steamers since 1933, trucks and other large vehicles had to be carried on rail barges. The *Delmarva* was first launched on November 2, 1933, equipped with double doors at both ends and 13-foot clearance to accommodate all vehicles. She was propelled as fast as 18 miles per hour by uniflow engines that could generate more torque at slow speeds and fewer revolutions at cruising speeds. At a cost of $600,000 and a length of 249 feet, she could carry 1,200 passengers and 90 automobiles. The *Delmarva* continued in operation as designed until 1954, when the same additions that had been made to the *Princess Anne* were accomplished in the Baltimore shipyard. (Courtesy of Robert Lewis.)

The 282-foot *Pocahontas* was built by the Pusey and Jones Company of Wilmington, Delaware, and made her first run as the flagship of the fleet on March 9, 1941. At a cost of $1,225,000, she was slightly faster and larger than the *Delmarva*, with a cruising speed that topped out at 19 miles per hour and capacity for 100 automobiles. Like the *Princess Anne* and *Delmarva*, she, too, was cut in half and lengthened by 76 feet in 1957. (Courtesy of Robert Lewis.)

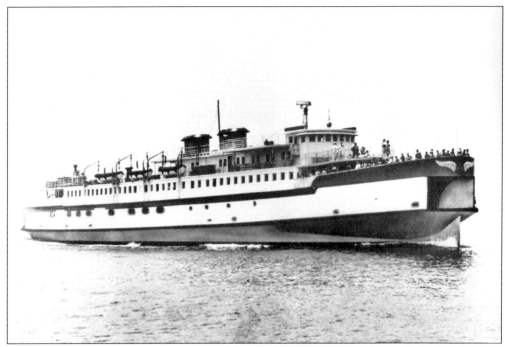

Similar changes converted the steamer *Virginia Lee* into a new ship called the *Accomac* (above), and the passenger and car ferry *Northampton* was added to the fleet. The *Northampton* (below) was built in 1943 as LST-63 for the federal government. LSTs—or Landing Ships, Tanks—carried troops and supplies to both theatres of World War II and were well suited for postwar adaptation to other uses. In the fleet of the VFC, she had the capacity for 60 motor vehicles and 600 passengers. In 1964, she left the bay for work off the coast of Mexico. (Cape Charles Historical Society.)

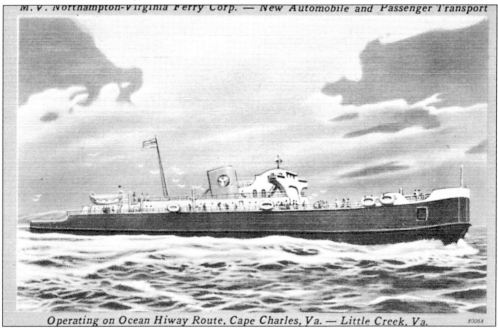

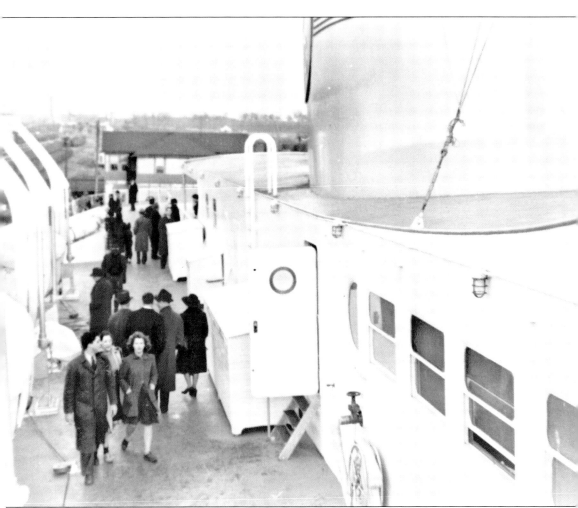

Passengers walk the decks of *Pocahontas* at Kiptopeke in the 1960s. Though the new ferries were faster and more attuned to automobile travel, they did not seem to many to retain the romance of their predecessors. A writer to the *Washington Star* in 1971 responded to a newspaper article about the *Virginia Lee–Accomac* conversion: "Anyone seeing the forlorn picture [of the *Accomac*] which accompanied the article would never recognize the once proud lines of the *Virginia Lee* in that pathetic hulk. . . . I remember watching from the sleek prow the sun come up over the bay. I remember watching from the stern as the fish—dolphins I think—leaping high in the air as they followed our wake, picking up food. . . . Then the Navy took her. The rest is legend." (Eastern Shore of Virginia Historical Society.)

Motor traffic lines up for passage on the Kiptopeke Ferry at Little Creek in 1959 (above), and at the Kiptopeke end of the ferry ride (at left), a truck emerges onto a smaller docking area. Over the preceding years, the ferry service across the bay had come to be seen more as a necessity than a convenience, and traffic increase on the ferry line demonstrated the need for even more efficient travel across the bay. That would come in the form of a bridge-tunnel that would be seen as an undertaking as audacious as the original NYP&N in 1884. (Top: Courtesy of Robert Lewis; bottom: Eastern Shore of Virginia Historical Society.)

Eight
Last Rides

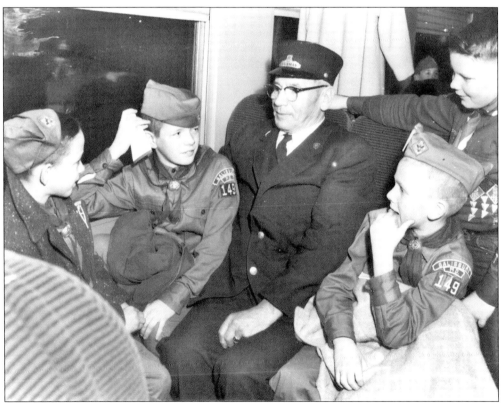

Passenger train service into the 1950s had been supported in part by contracts with the U.S. Post Office to carry the mail between Delmar and Cape Charles. When that contract was lost in 1957, the PRR elected to discontinue the last of the passenger trains on the run to and from Cape Charles. The caption for this newspaper photograph reads: "E. B. (Block) Daugherty regales scouts with railroad stories on 454's last run up the peninsula, January 11, 1958." (Eastern Shore Railway Museum.)

In the late 1950s, the structures that had worked for the railroad and the people who used it had fallen into disrepair. The Brooke Avenue Station in Norfolk was shuttered and abandoned in 1959. (Kirn Library, Sargeant Memorial Room.)

Highballs were among the earliest of train signals, consisting of a ball that was run up a pole to inform the engineer that the track ahead was clear. "Highball" came to apply to the use of signal lanterns that meant "Come Ahead," "Leave Town," or "Pick Up Full Speed." Used as a verb or in the phrase "ball the jack," it meant "make a fast run." This one was positioned near the superintendent's office at the Cape Charles Station but was dismantled and moved to Delmar when the station was torn down in November 1959. (Cape Charles Historical Society.)

The shops and roundhouse at Cape Charles were torn down in 1960. The following decade was to bring continuing losses to the railroad and to Cape Charles by extension. By this time, the number of freight cars moved across the bay had declined to 50,000. Steam-driven tugboats were sent to scrap yards and replaced with diesels drawn from the PRR's New York harbor fleet. In 1968, the PRR and the New York Central Railroad, both in financial difficulty, merged to become the Penn Central. (Cape Charles Historical Society.)

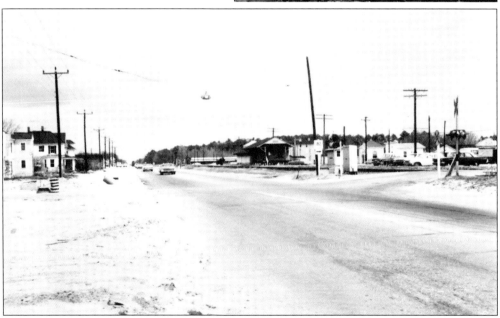

Development of U.S. Route 13 through the small towns served by the railroad brought gasoline-powered competition to diesel-powered locomotion. In Painter, shown in 1968, the town's small railroad station sits at an intersection with the increasingly traveled highway. (Photograph by Robert Lewis.)

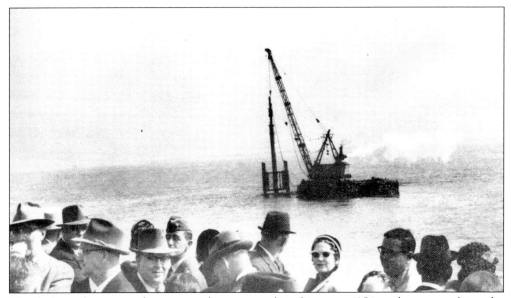

The decline of passenger ferry service became a political issue in 1954, and two years later, the Commonwealth of Virginia acquired the VFC through a transfer of assets. The new Chesapeake Bay Ferry Commission soon turned its attention to an alternative crossing of the bay. On September 7, 1960, as the shops were being taken down in Cape Charles, the first pylon of what would become the Chesapeake Bay Bridge-Tunnel (CBBT) was driven into the bay near Kiptopeke, an event witnessed by guests and dignitaries.

The CBBT was to run 17.6 miles from the tip of the Eastern Shore to Virginia Beach. It would include two one-mile tunnels, four man-made islands, and 12 miles of trestle supported by 2,598 cement pylons manufactured at the Bayshore Concrete Plant in Cape Charles Harbor. (Eastern Shore of Virginia Historical Society.)

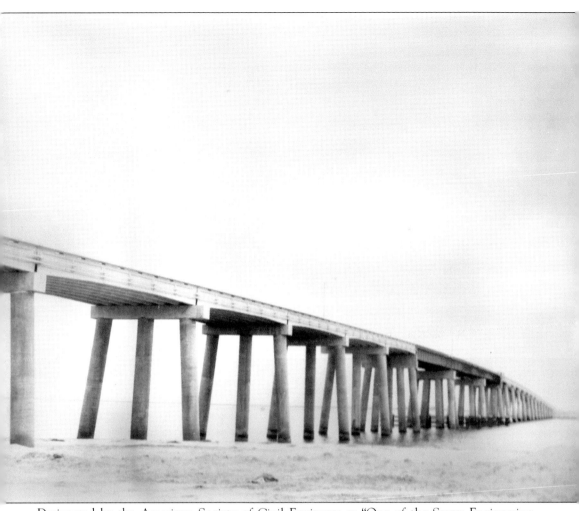

Designated by the American Society of Civil Engineers as "One of the Seven Engineering Wonders of the Modern World" in 1965, the complex was built at a cost of $200 million and financed by toll-supported revenue bonds sold to private investors. No public money was used. What had been at least a 90-minute ferry crossing of the bay would now take 25 minutes by car. It would be named the Lucius J. Kellam Jr. Bridge-Tunnel in August 1987 in honor of the man who, like Alexander Cassatt before him, had converted an impossible vision into a reality. In 1995, construction of a parallel roadway was begun that would allow two-lane traffic in both directions, merging through the original tunnels. That construction would be completed in 1999, and 40 years after its opening in 1964, the complex would carry 80 million vehicles across the water. (Eastern Shore of Virginia Historical Society.)

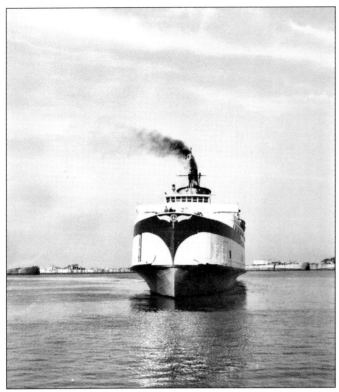

Opening ceremonies for the new bridge tunnel took place on one of the ferries it would eventually replace. The *Pocahontas* had been put into service on the Cape Charles–Little Creek run in 1941. Two days after she was used to stage the CBBT's opening on April 15, 1964, she was renamed the *Delaware* and moved to the route between Lewes, Delaware, and Cape May, New Jersey. Over 31 years of operation, ferries between Cape Charles or Kiptopeke and Little Creek had safely carried 14 million vehicles and 41 million passengers. Only three people had lost their lives as a direct result of ferry operations during that time. (Eastern Shore of Virginia Historical Society.)

CHESAPEAKE BAY BRIDGE TUNNE

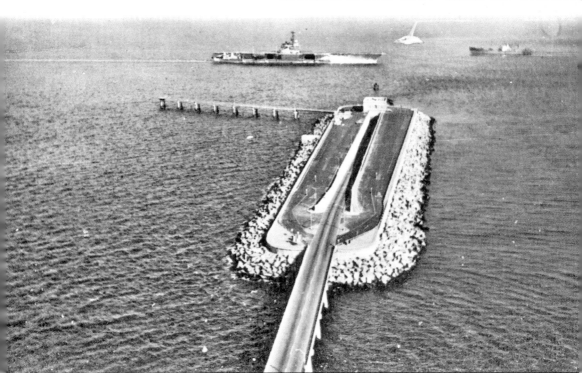

A postcard view of the CBBT shows a south island entrance to one of its tunnels beneath a shipping channel of the lower bay. The aircraft carrier, outbound from the Norfolk Naval Base, and an inbound freighter both represent the historic work of the Hampton Roads harbor 10 miles inland. The dramatic success of the early years of the railroad, its ferries, and its barges had played a large role in the thriving business of the port. As the railroad declined and the CBBT opened, the port was exceeding the import traffic of any other mid-Atlantic port (38 million tons in 1962). In 1964, it exported 40 million tons of coal and saw 6,000 ships come in from the sea and over the CBBT tunnels to its piers. (Cape Charles Historical Society.)

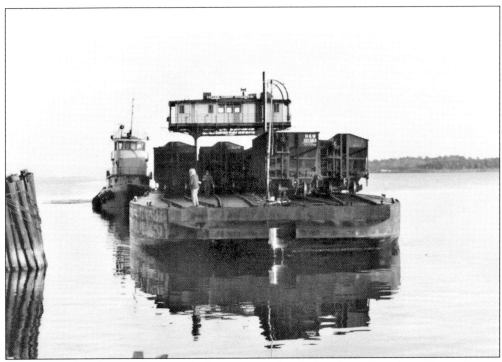

In 1961, freight movements across the bay were on the decline but still active. Above, the tug *Philadelphia* and car float *Capt. Edward Richardson* arrive at Little Creek, and below, Barge No. 608 is loaded by a Baldwin S-12 locomotive for the journey to Cape Charles. (Cape Charles Historical Society.)

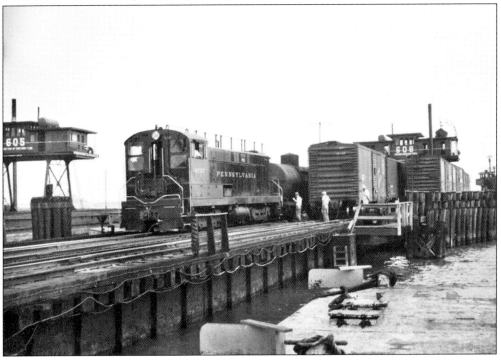

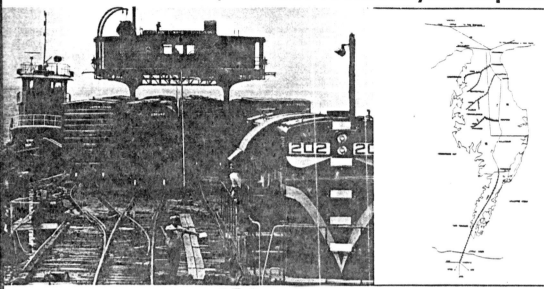

In 1973, the U.S. Congress attempted to stop continuing deterioration of railroads, the Penn Central in particular. The Penn Central had been formed from the PRR and the New York Central in 1968, but it faltered, and legislation was passed that would bolster it and other railroads through the formation of the Consolidated Rail Corporation. Conrail took over operation of the Delmarva system north of Pocomoke on April 1, 1976, and ran the railroad south to Cape Charles under contract for the Accomac-Northampton Transportation District (ANTDC), which wanted to preempt a possible abandonment of the line. A year later, the newly formed Virginia and Maryland Railroad (VAMD) was contracted to operate the system. In 1981, ANTDC purchased associated real estate and marine equipment from Penn Central, terminated the VAMD contract, and formed the Eastern Shore Railroad (ESHR) as an operating subsidiary.

A VAMD locomotive pulls an old passenger car outside of Onley on June 8, 1979. This was a VIP ride with shippers, government officials, and officials of other railroads wined and dined in an old wooden baggage coach belonging to the railroad's president. What would go on to become the ESHR would move into the next century on difficult financial footing. In 2005, it had been running in the red for years, and its owners, a public commission of Accomack and Northampton Counties, were seeking operating proposals from interested parties. Quoted in the *Eastern Shore News* of July 13, 2005, one of the commissioners called it "a wasting asset," one that devalues over time. He wondered aloud if the railroad could continue to run in the red just to preserve local businesses. (Courtesy of Robert Lewis.)

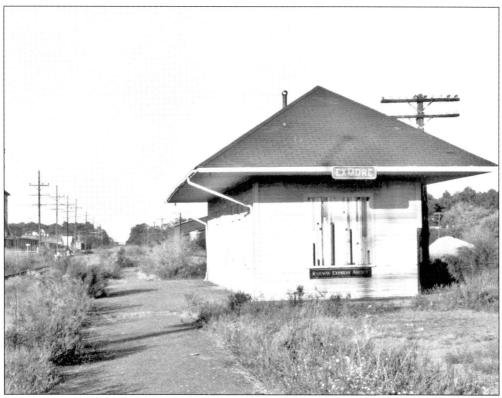

The passenger stations at Exmore and Salisbury still stood in 1976. The remnants of some of the stations and their related buildings lasted into the 21st century. Though often unrecognized and unnoted, they could be seen from speeding cars on U.S. Route 13 or in the back streets of small towns. (Courtesy of Robert Lewis.)

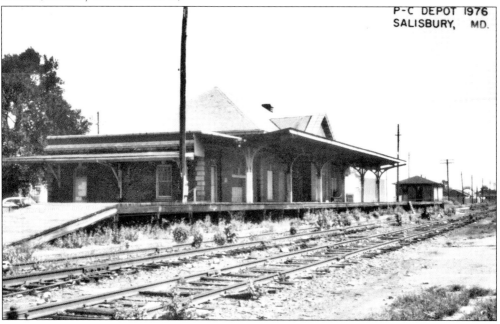

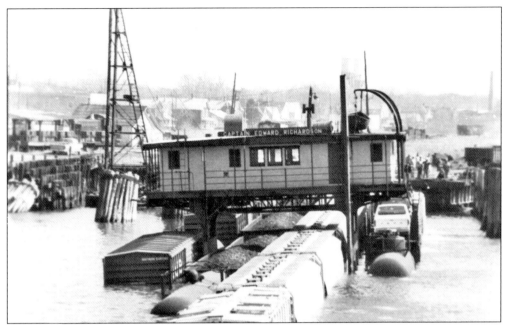

A newspaper account of the sinking of the *Capt. Edward Richardson* at Cape Charles on March 13, 1981, offers a revealing portrait of the nature of freight operations at that time. It carried five coal cars, five cars of polystyrene powder, two cars of nitric fertilizer, and single carloads of cotton-seed oil, pulp board, fiberboard boxes, phosphates, and a supply of 1981 Ford trucks produced at the factory in Norfolk. (Eastern Shore Railway Museum.)

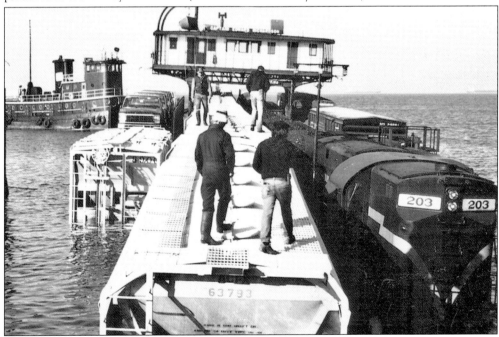

The barge had begun to take on water in the bay but made it to the docks before sinking in 25 feet of water. Though most of its cargo, and the locomotive, remained initially above water, subsequent high winds would eventually sink the entire load. (Cape Charles Historical Society.)

Recovery was accomplished with the work of divers and cranes. The sinking interrupted several days of movement across the bay, though some freight was diverted to other routes, and it came at a delicate time. A state-authorized body was attempting to obtain a $10.3-million loan from the Farmers Home Administration that would save the line as the ESHR. In October of the same year, the barge sank once again in transit across the bay. One life, 24 tank cars, and the pilothouse were lost. The barge was recovered and renamed the *Nandua* in 1987. (Top: Cape Charles Historical Society; bottom: Eastern Shore Railway Museum.)

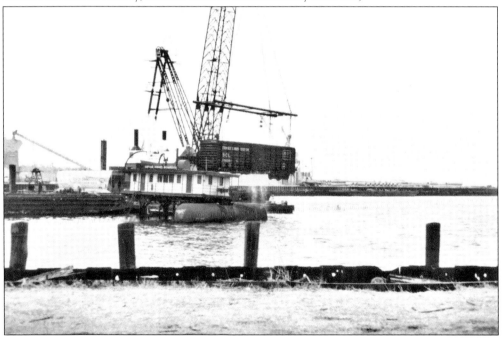

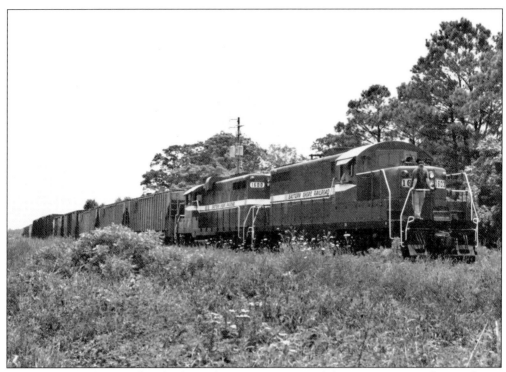

As the Eastern Shore Railroad, Alexander Cassatt's vision of the 1880s continued its work as a freight hauler into the 21st century and paralleled U.S. Route 13 through farm and forestland for much of the way. (Eastern Shore Railway Museum.)

By 1980, the population of Cape Charles had been reduced to 1,512, its lowest since 1905. The busy complex of piers and repair shops had long since disappeared, and the main station had been torn down in November 1959. The Mason Avenue commercial district still stood, though its buildings were not fully occupied. The freight train and barge operation moved about 50,000 cars per year by mid-decade. Coal from the coal piers of the C&O in Newport News and of the Norfolk and Western in Norfolk was a major export of the Port of Hampton Roads that sat to the southwest across the water, much of it moved through Cape Charles. (Eastern Shore Railway Museum.)

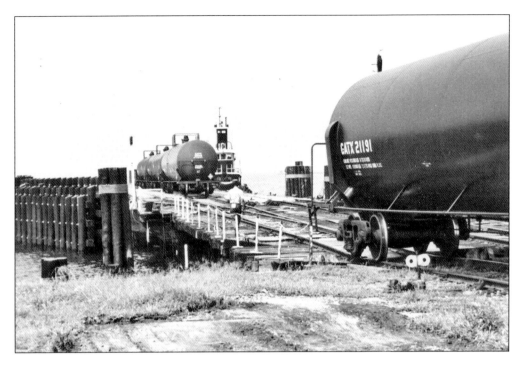

Barges were still being loaded and moved abreast by tugs out of the harbor, though business would continue to decline into the 21st century. The railroad operated in the red, as it had for years, and annual car handlings had decreased by 28 percent from 1999 to 2005. (Courtesy of Robert Lewis.)

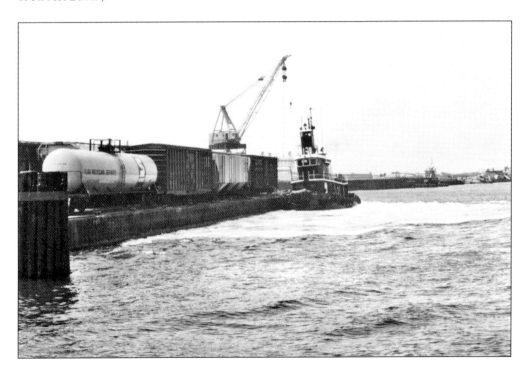

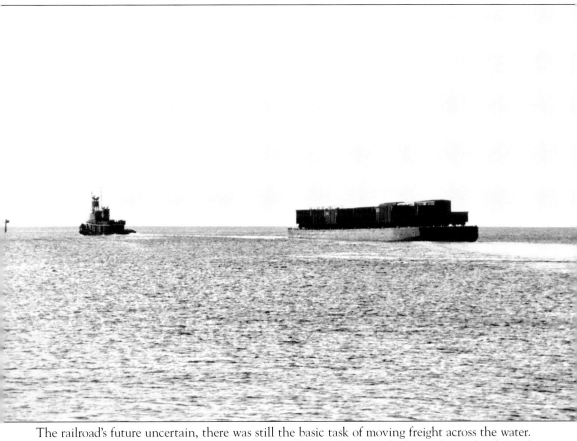
The railroad's future uncertain, there was still the basic task of moving freight across the water. As it had for more than a century, the formation still moved out into the bay and past the channel markers, looking no different at a distance than it did in 1884. (Courtesy of Robert Lewis.)

Having developed an audacious railroad in 1884, Alexander Cassatt went on to become president of the PRR in 1899. He doubled the railroad's assets, four-tracked its major routes, initiated the Hudson River tubes and Pennsylvania Station in New York, redesigned other terminals, eliminated grade crossings, and built flyovers. He died in 1906. The Cassatt Tower, named in his honor, sits alone beside the track in Pocomoke City. The picture is undated. (Eastern Shore Railway Museum.)